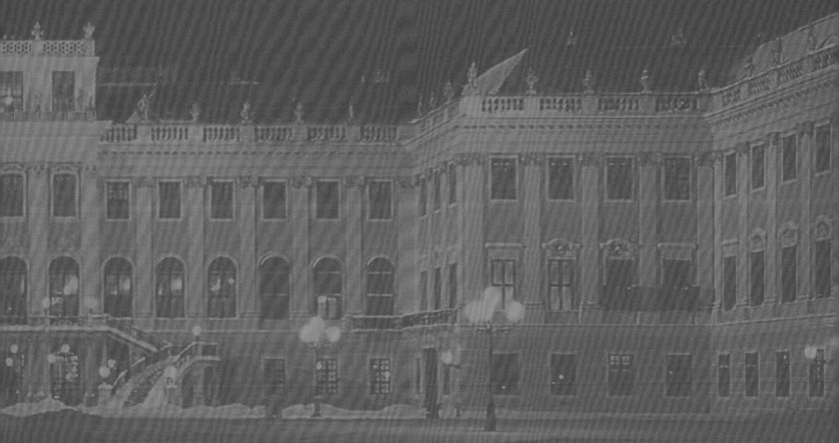

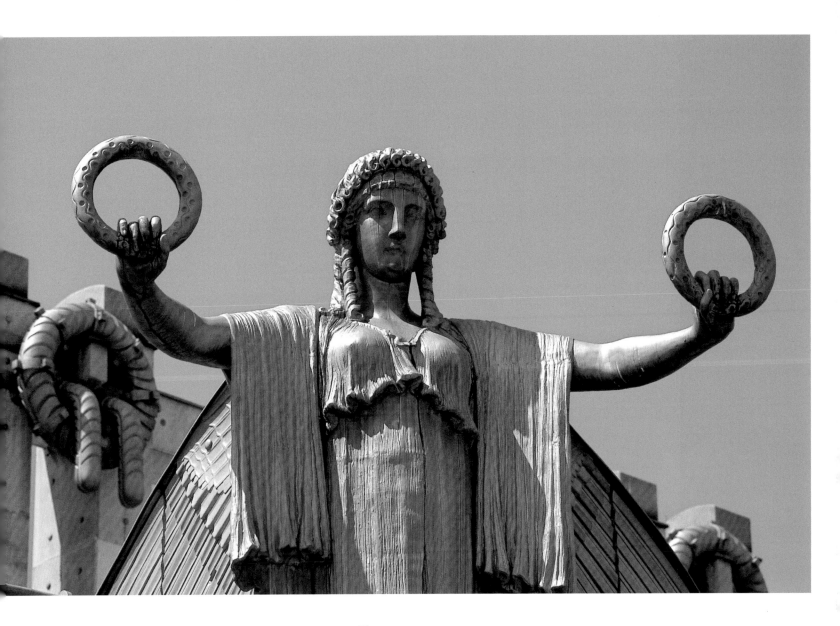

FASCINATING

VIENNA

PHOTOS BY

JÁNOS KALMÁR

TEXT BY

MICHAEL KÜHLER

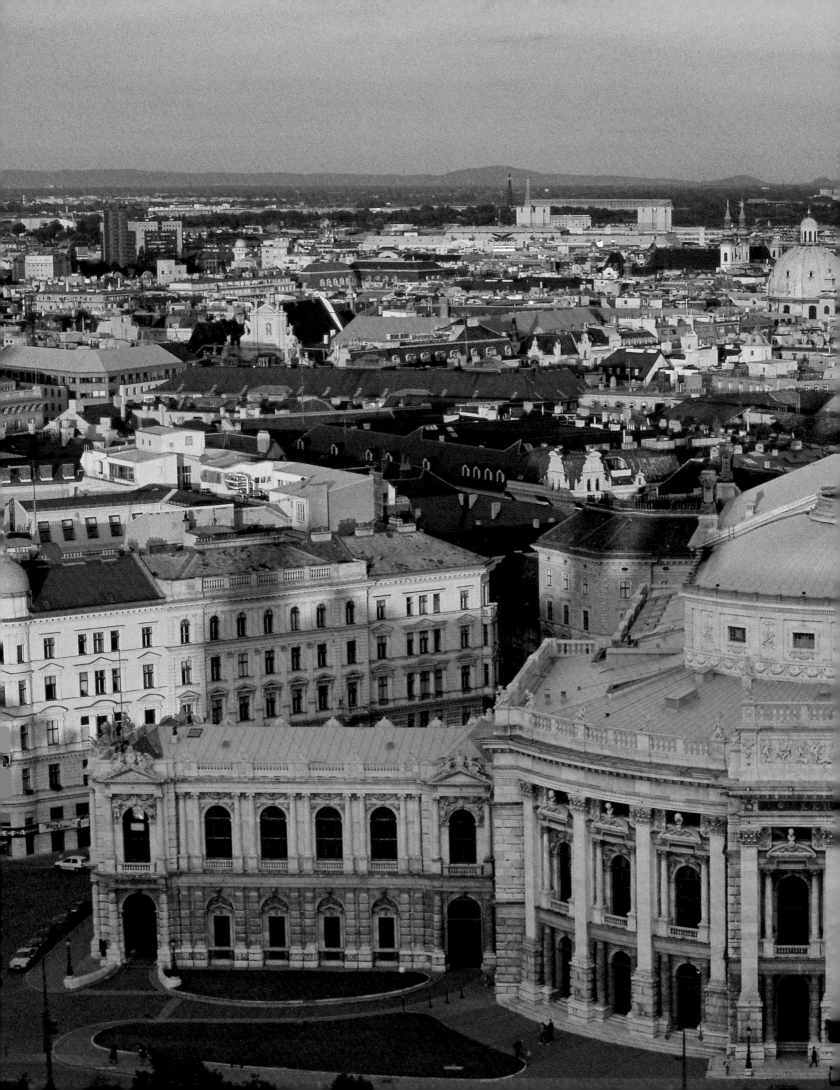

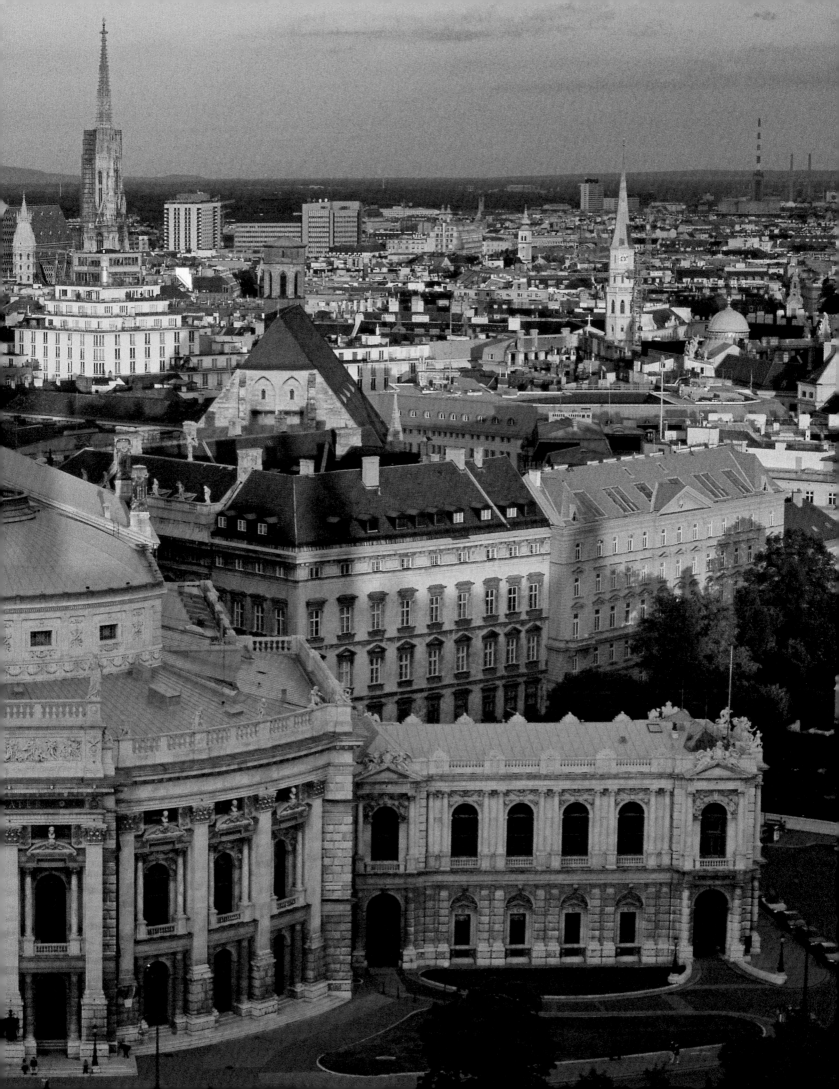

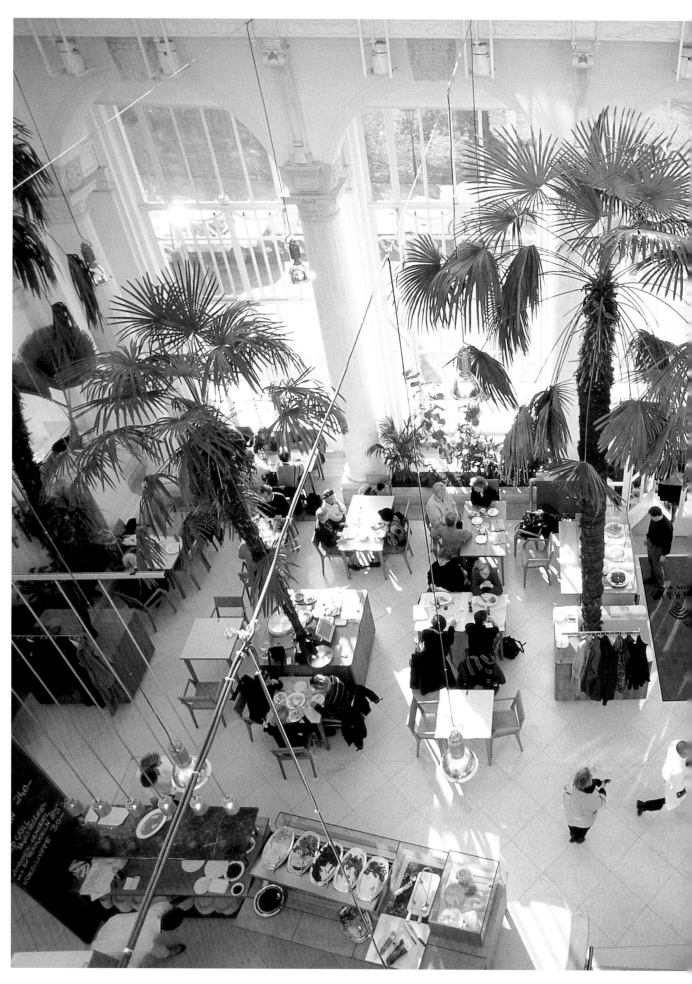

First page:
Elegant statues reminiscent of Ancient Greece crown the Postsparkassenamt in Vienna. The savings bank is the chief work of architect Otto Wagner and one of the most famous Jugendstil buildings in the city. Wagner's rooftop acroteria were also a trait of the Renaissance, neoclassical and Historicist periods.

Previous double spread:
From the tower of the Rathaus (town hall) on Ringstraße there are grand views of the first Viennese district and the Burgtheater. The Ringstraße was laid out along the lines of the demolished city defences and adorned with palatial Historicist villas. Vienna's historic old town lies within the Ring boulevard.

Right:
Behind the sparkling glass facade of the palm house in the Burggarten you can savour and celebrate the culinary delights of Vienna – prepared in the open kitchen – in a unique and pleasant setting.

Page 10/11:
Otto Wagner was commissioned with the design of the first city railway stations in Vienna. The result is a magical melange of late Historicism and early Jugendstil. The magnificent example on Karlsplatz is no longer used as a station for the Wiental line but has nevertheless been carefully restored.

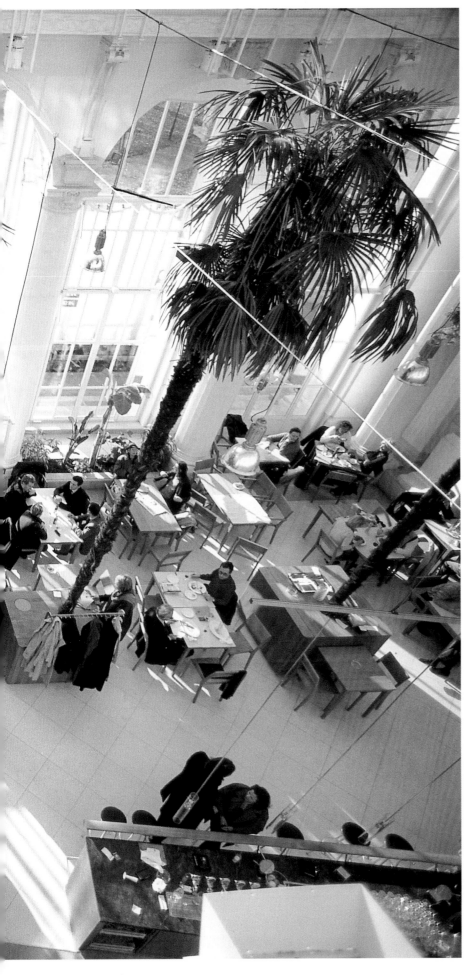

CONTENTS

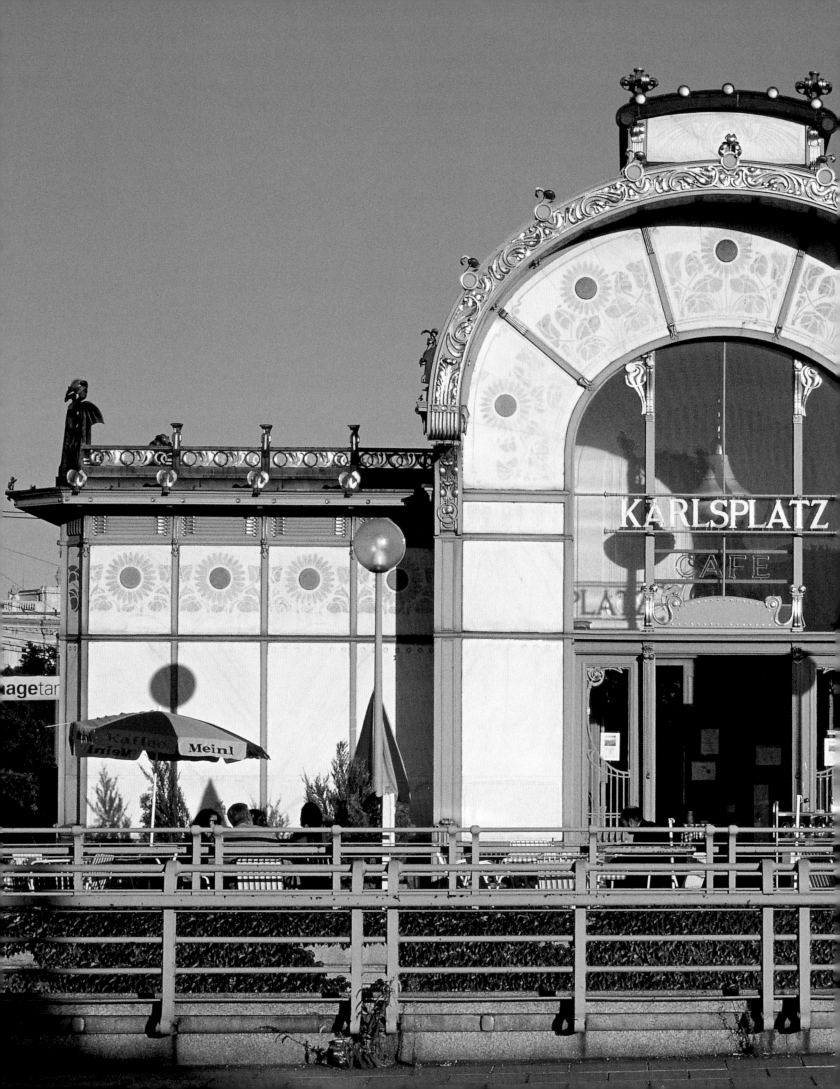

May I have the honour?

Over the past few centuries Vienna has had the honour of being able to call many world-famous personalities its own, among them Ludwig van Beethoven, Wolfgang Amadeus Mozart and Sigmund Freud. Drawn by these noble gentlemen – and others – many less illustrious visitors continue to flock to the Austrian capital year in, year out. While on their travels they may be greeted by a number of rather formal and often antiquated modes of address; a quaint "May I have the honour?" or "With whom do I have the pleasure of speaking?" are not uncommon. Even official titles, such as Frau Doktor or Herr Hofrat are still in widespread use – even though they were abolished in 1919.

This sense of courteous ceremony is a possible remnant of the age of the Habsburgs, in whose dominions the sun was claimed never to set. The Habsburgs – and before them the Babenbergs – were not the first to adopt Vienna as their official residence; human inhabitance of the Vienna Basin can be traced back to the Stone Age.

There followed a Celtic settlement of Vedunia and late a Roman fort of Vindobona – and in time the quirks linguistic development produced the present name Wien or Vienna.

The first history of the city was penned in 1280. In h Fürstenbuch Jans der Enikel or Jans the Grandso describes himself as a "true Viennese" and tells minnesong at court. He was not the only one to sing th praises of his native town; the many composers operettas and waltzes, coffee house poets and Austria very own queen of hearts Empress Elisabeth or Sis were also to make Vienna as famous as did the father psychoanalysis Sigmund Freud.

The beautiful blue Danube

Vienna is situated on the beautiful blue Danube – eve if this isn't immediately apparent when you first look a map. On the plan the city seems to have turned i back on the river – purely for practical reasons and no from choice. Countless floods have made it necessary t tame the torrents and keep it out of harm's way. A toke channel of the Danube (the Donaukanal) still meande through the city centre, however, and the Donauinse between the Neue and Alte Donau has become a to destination for city dwellers wanting to escape th metropolis for a few hours. Not far from the Danube another hot favourite and Vienna's best-known attrac

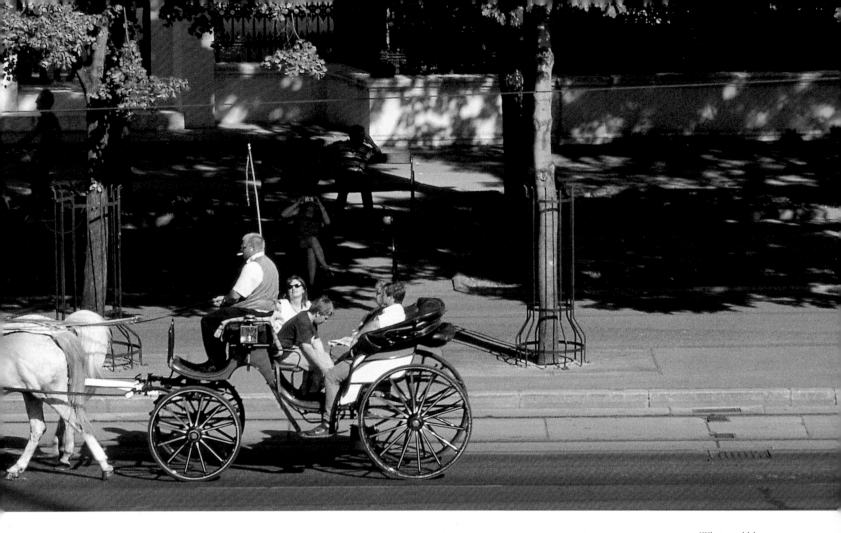

on: the huge Ferris wheel at the Prater funfair. A good undred years old, it can still gamely compete with the nore modern big dippers, computerised fruit machines nd other newfangled fairground contraptions.

To die for: the Zentralfriedhof

's said of the Viennese that they like to live well and to ie with honour and ceremony. The city's very own death ult is fittingly commemorated at both the funereal nuseum (Bestattungsmuseum) and the Zentralfriedhof, ne of the biggest cemeteries in the world.
inger-songwriter Wolfgang Ambros paid tribute to this norbid place on the occasion of its hundredth jubilee in 974; the Zentralfriedhof has also provided a bleak ackdrop for films such as *The Third Man* with Orson Velles. The list of prestigious graves is long and many nusic lovers flock to this enormous burial ground to the nal resting places of Beethoven and Schubert. The two mous composers were originally interred at the ceme-ery in Währingen and later moved to their present ocation. The most recent 'state burial' in the presidential ault was in 2007 when a 'forgetful' Kurt Waldheim was aid out at the age of 88. He wasn't given a state funeral s his period of office ended in 1992.
he last Habsburg empress, Zita – who, like her hus-and, never abdicated – was also entombed according to radition in the Kapuzinergruft in 1989; the gatekeeper,

however, refused to admit the body until the grand title of "Her Imperial Majesty" had been turned into a more modest "repentant sinner". As with her ancestors before her, her heart was buried in the Augustinerkirche and her entrails in the cathedral. Less prominent but no less poignant than the Kapuzinergruft and Zentralfriedhof is the cemetery of the nameless where until recently suicides and murder victims washed up by the nearby Danube were laid to rest.

Above stairs on Ringstraße and between stairs on Gürtel

The Habsburgs lived and represented their dynasty and empire in the Hofburg and Schloss Schönbrunn, Vien-na's answer to Versailles. Both palaces pull the crowds from all corners of the globe, as does Steffl, the cathedral dedicated to St Stephen, and the magnificent villas along Ringstraße which encircles the narrow streets of the old town. At these stately homes the first floor or "above stairs" was kept for the use of the aristocracy only, with the kitchens below stairs and the private apartments above.
Ringstraße traces the foundations of the old town walls; Gürtelstraße was laid out along a line of defence intended to protect Vienna from the Turks. Here a number of ten-ements were built which display a Viennese peculiarity: the mezzanine. In order to cut the taxes owing per storey

What could be more relaxing than a ride with a Fiaker along Ringstraße and the boundaries of Old Vienna? The city's mean-dering horse-drawn taxis can stop wherever you wish – perhaps outside the neoclassical parliament building on Dr.-Karl-Renner-Ring where this photo has been taken.

The Volksgarten on the Ring was originally designed as a private garden for the city's archdukes and became the first royal park to be opened to the public. The strict geometric layout of the paths enabled guards to keep a careful eye on visitors. The gardens are dotted with statues and monuments, one being for Austria's very own Princess Diana, the equally tragic Empress Elisabeth.

an interim floor was inserted between the ground and first floors. However, not only private landlords dreamed up ingenious ways of saving money; the council members of Vienna's Neues Rathaus also knew how to keep a tight hold on their cash during the 19th century ...

Einspänner, Fiaker and Pharisäer

Thrift is also a plausible option when you pay an extended visit to one of Vienna's many coffee houses. On correct pronunciation of the German word *Kaffee* (with the accent on the "ee" and not the "a", like French *café*), on proper address of the waiter in his crisply pressed tails ("Herr Ober!") and on ordering an *Einspänner* (mocha with cream) or even a *Pharisäer* (with a shot of rum), you will be given a glass of tap water free with your beverage. It then becomes possible to make your coffee last for ages while you browse through the free newspapers or talk business with colleagues and associates while lounging in old leather sofas.

Taking your work to the coffee house is tradition in Vienna. In 1867 prime minster Auersperg decreed that the contents of newspapers be more strictly scrutinised than had been the case. Where better to do this than at Café Central or at the Imperial, at Landtmann's, Hawelka or Griensteidl? Café proprietors were keen to waylay their new clientele as long as possible and thus also subscribed to papers with a revolutionary bent;

civil servants who spent less time in the office and mor time allegedly censoring the press at the *Kaffeehaus* wer thus considered to be especially diligent.

However comfortable, tourists are advised not to whil away the day at the coffee house alone; there's plent more to see and do here! If you fancy a lazy trip roun the Altstadt, you could hop aboard a horse-drawn ca riage chauffeured by a *Fiaker*. Another absolute must an evening at a *Heuriger* or wine tavern, perhaps i Grinzing, an experience guaranteed to be less serene bu with a lively atmosphere and plenty of new wine to sen you merrily off to the land of Nod ...

Sachertorte, anyone?

Dreams are not only sweet at the legendary Hotel Sache or even more luxurious Hotel Imperial. Even in th heart of town there are plenty of small guesthouses wit prices which are much more affordable than the bi names. The aforementioned Hotel Sacher is famous fo *Sachertorte* – or death by chocolate in Viennese. Th degree of authenticity of this particular *Sachertort* has long been and still is the subject of sticky debat between Sacher and the equally famous Café Deme May the dual of the cake forks commence ...

Suitably sustained, the cultural highlights of Vienn await. Recent years have seen the opening of an Empres Sissi museum at the Hofburg. Here you can marvel at th

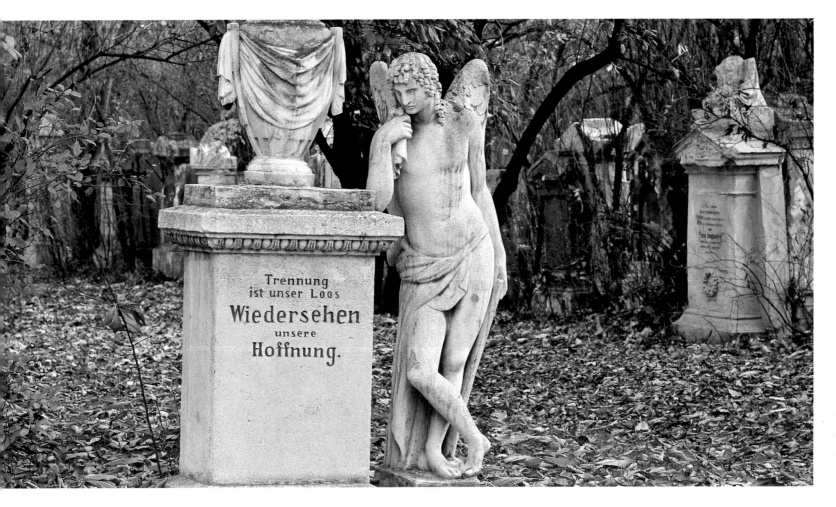

Trennung
ist unser Loos
Wiedersehen
unsere
Hoffnung.

rivate artefacts once wielded by the empress of Austria nd queen of Hungary, she of the extremely long hair nd crazed dieting. Besides her baby shoes, cocaine oxes and mourning fans there is also the gym apparatus he had erected in her personal dressing room. Unfortu- ately, you're not allowed to use them to work off those xtra pounds collected at the coffee house and *Heuriger*. Vhat would help beat the bulge is a visit to Schönbrunn. Iowever, once you've trailed the huge palace, the xtensive grounds and the oldest zoo in the world on oot, you'll feel like another slap-up dinner to restore our spent energies. No less interesting but perhaps less rowded are the palaces Oberes and Unteres Belvedere. Originally built for Prince Eugene of Savoy, among other hings they now house a museum of the baroque.

Take the floor, please!

n Vienna the irrepressibly joyous spirit of the baroque s somewhat dampened by the modest understatement of he Biedermeier period. It all began in 1814/15 with the Congress of Vienna which created not only a new polit- cal order in Europe following the defeat of Napoleon ut also made the flamboyant and effusively colourful /iennese waltz socially acceptable throughout the ball- ooms of Vienna, Austria and the world. The post- Napoleonic map may have been redrawn several times ince then, but still the dance goes on. At the end of

February young debutantes twirl furiously across the floor in three-four time at the yearly Opernball. Around 5,000 visitors from across the globe come to the biggest social event in Austria, held at the state opera house. The extortionate 'ticket prices' for a seat in a box (usually a five-figure number) are the subject of hot debate, as is the honorary guest list, which has included *grandes dames* such as Sophia Loren and young starlets such as Paris Hilton. Those who wish to follow the goings-on without having to take out a second mortgage can browse through the paper of their choice over a cup of *Großer Brauner* or *Verlängerter* at the nearest coffee house ... The many others who consider the dance floor – however fine – an inappropriate location for meetings, discussions or working lunches can still 'diligently' escape the office at one of the many *Beisl* pubs in and around Vienna, where local food is served at prices which are definitely affordable! The *Schanigarten* is another favoured venue, where you can relax over a good meal and a drink or two in courtyards enclosed by vine-covered walls.

To the Vienna Woods on the Bim

When the Viennese wish to escape their native city for a few hours, many hop on a tram or the Bim, as it's known here, and take to the woods. By tram the journey out into the city's green belt may take a while; for those with less time to spare the S-Bahn or Bundesbahn railways

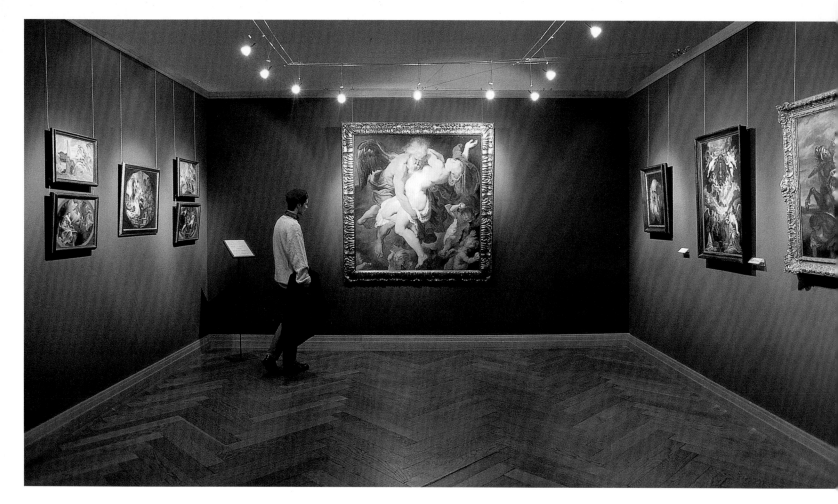

Above:
Peter Paul Rubens'
painting Boreas abducts
Oreithyia tells the tale of
a king's daughter stolen
by the north wind. As is
typical for the period of
the Counter-Reformation
the relationship between
the sexes is depicted in a
voluptuously erotic vein.

are good alternatives. Places such as the historic Mayerling, the wine village of Gumpoldskirchen, the Habsburg summer retreat of Laxenburg or the spa of Baden are all well known and popular with the locals.

The rooftops of Bratislava were also known as the Vienna Woods due to the vast number of TV aerials turned to face Vienna in the days when the Iron Curtain divided East and West. The capital of Slovakia is now a great place to visit for the Viennese and their guests. Here you can also sail along the Danube on one of the pleasure boats run by the company with the infamous and incredibly clumsy former name of *Donaudampfschifffahrtsgesellschaft.*

city's makeup – as did Alfred Loos whose rigorousl objective style of building was not an immediate h with the Viennese and the royal court.

A few decades later the critics again sharpened thei tongues, this time claiming that Friedensreich Hundert wasser was an artist who had yet to develop an individua style. His Hundertwasserhaus is now, however, clearl discernible as his and no-one else's and is one of Vienna major attractions. Another long-lasting yet immediat triumph of local creative genius were the bentwoo chairs designed by Michael Thonet – which 150 years o still grace the coffee houses of Vienna.

From the Vienna Secession to Hundertwasser

Page 18/19:
In the mid 1880s Otto
Wagner erected his first
Villa Wagner with windows
designed by Adolf Böhm.
The present owner of the
villa, artist Ernst Fuchs,
founded the School of
Fantastic Realism with
Arik Brauer in 1959,
making the house his own
by filling it with fertility
statues and vibrant colour.

Once you've returned from your travels abroad there's lots more to look forward to in Vienna itself. The severe architecture of the Karl-Marx-Hof in the 'red' Vienna of the 1920s is just as exciting as the equally enormous museum quarter opened just a few years ago. It's heralded as one of the largest cultural complexes in the world and houses modern works of art from the beginning of the 20th century to the present day.

The Vienna Secession is slightly older and refers to a unique artistic movement active in Vienna at the turn of the 19th century. Its most famous advocate was Gustav Klimt. With their stylish and decorative edifices architects such as Otto Wagner greatly contributed to the

Right:
As the name would
suggest, guests of state
and stars of renown lodge
at the Hotel Imperial on
Ringstraße whose visitors
book is proudly encased in
a glass dome. Originally
built for Duke Philipp von
Württemberg the palace
was reopened as a hotel in
1873 on the occasion of
the world exposition in
Vienna.

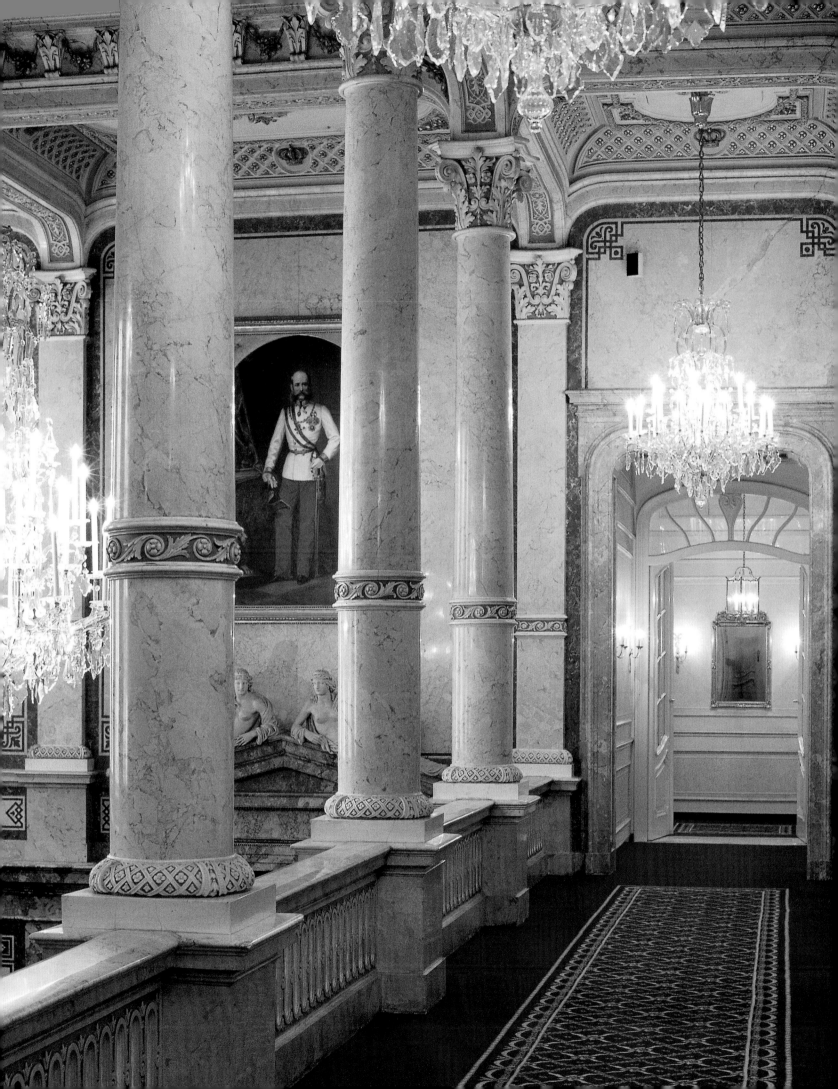

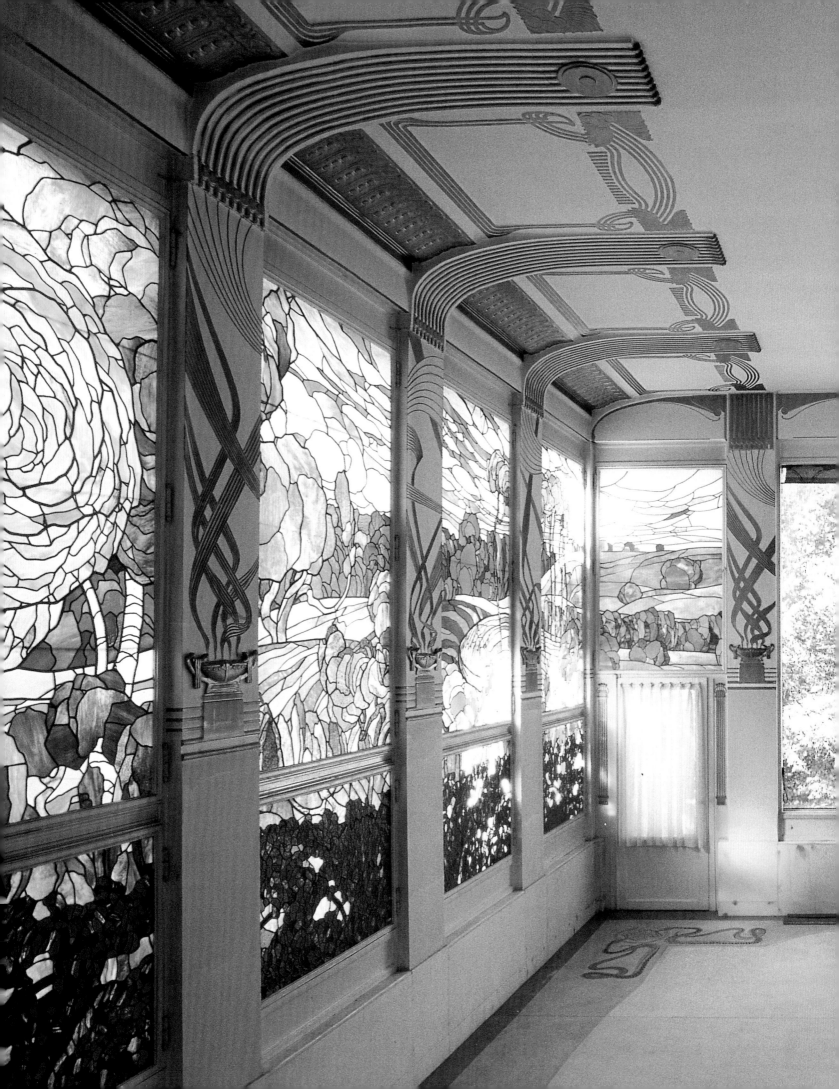

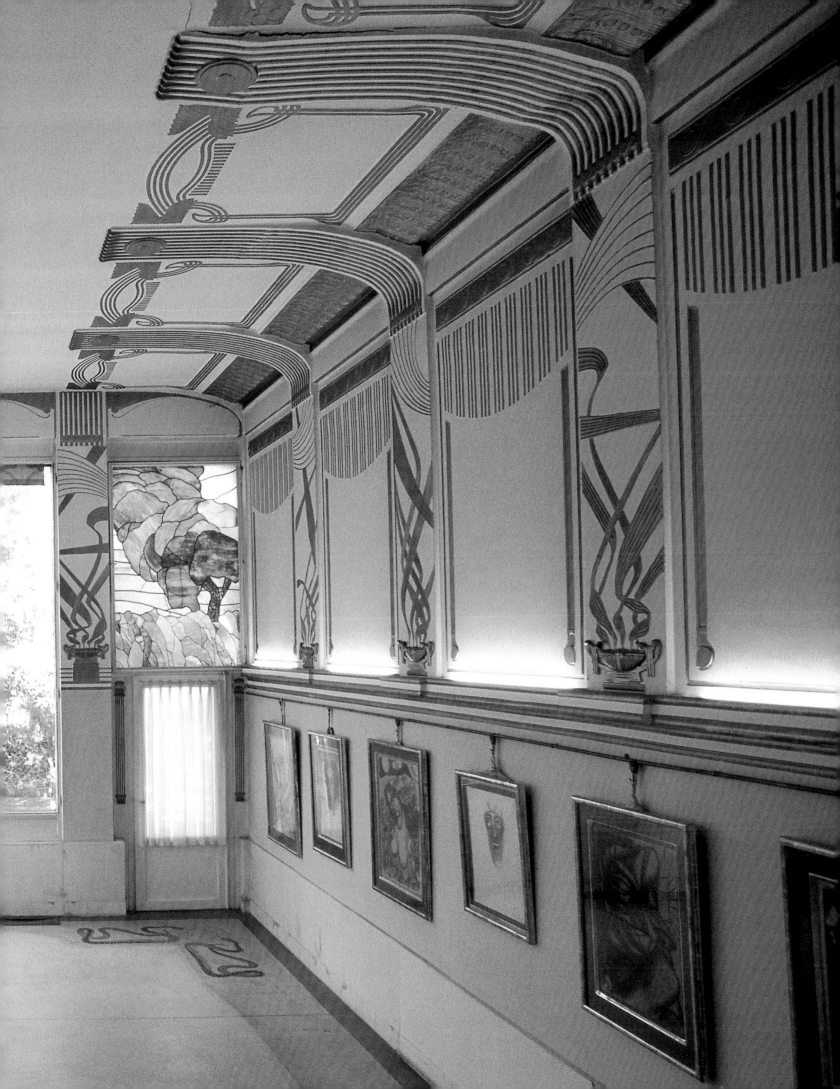

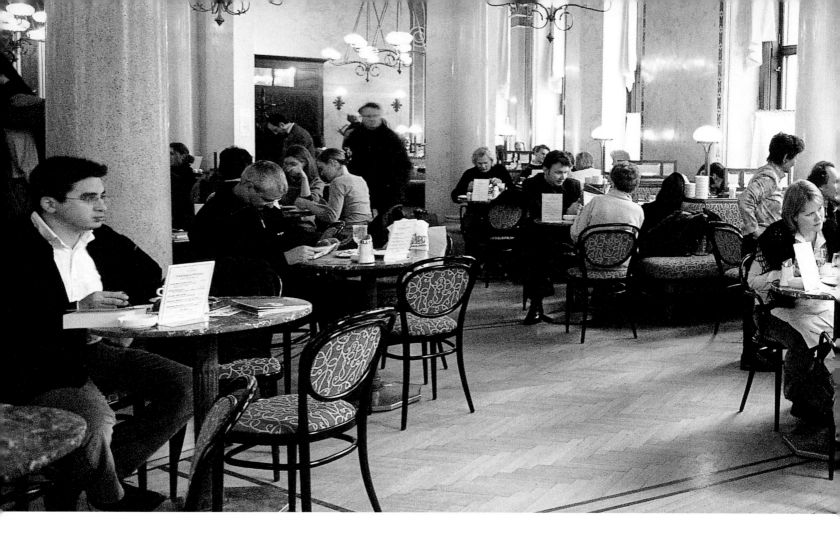

THE FIRST DISTRICT — THE HISTORIC CENTRE OF VIENNA

22 wards cluster round the inner city of Vienna or the *erster Bezirk* (first district) as it's collectively known. Until the first villages were incorporated in 1850 this area was once the total sum of Vienna which was then situated on the River Wien and not the Danube. The old Danube used to bypass the city; today it forms a boundary between the bustling centre and the sprawl of modern housing estates.

The most famous landmark of the Austrian capital is the Stephansdom or cathedral; the expansive complex of the Hofburg with its gardens and grounds is also well worth a visit. When the Habsburgs took up residence here the city was already over three thousand years old, its history dating from the Stone Age to the Romans to the Babenbergs.

Over the course of 600 years plus the dynasty built up a vast empire and made Vienna an imperial city, a distinction still evident in the city's many prestigious buildings and magnificent art collections. One of the most famous members of the Habsburg household was Empress Maria Theresa. She felt it necessary to form a chastity movement with which one well-known visitor to the city was not particularly enamoured. Giacomo Casanova was partial to strolls along the Graben, where by chance various nymph-like females could also be found in abundance. His conquests long thwarted, Graben, like Kärntner Straße, is now pedestrianised and a mecca for shoppers from far and wide. The narrow streets of the old town and nearby Naschmarkt are also popular with visitors and locals alike. The latter gets its name not from the fruit and vegetables sold here (German *naschen* means "to nibble") or from any kind of sweets; the older word Aschenmarkt or ash market is also deceptive. *Naschmarkt* is derived from Middle High German *asch* which means bowl or milk pail. Despite being beyond the main thoroughfare of Ringstraße this is the best-known of all of Vienna's squares and beneath it flows the river which gave the city its German name: the Wien.

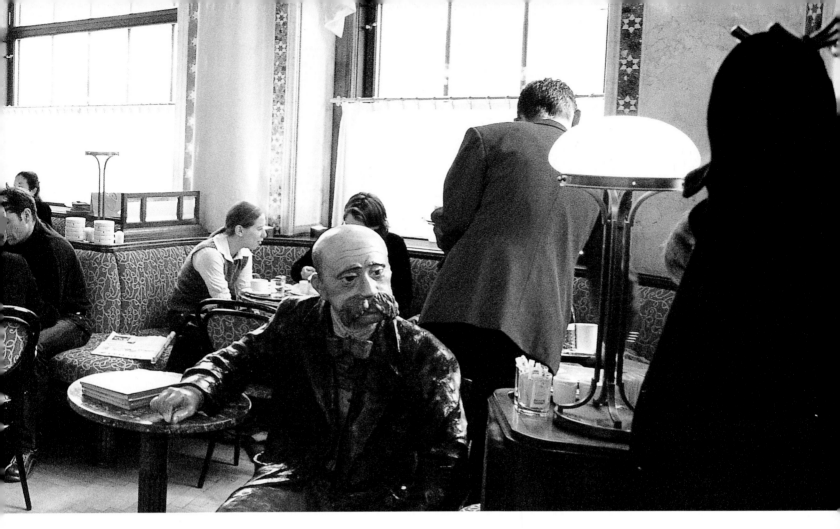

Above:
One of the many chess players to frequent Café Central at the beginning of the 20th century was Russian emigrant Bronstein. According to one famous anecdote he was not thought capable of provoking a revolution in his homeland; as Leo Trotsky he was to prove otherwise.

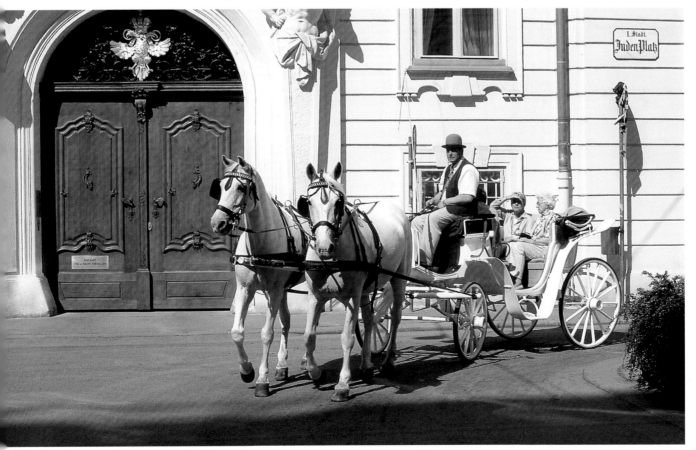

Left:
A ride on a Fiaker will take you past the back of the old royal Bohemian chancellery on Judenplatz, built by Fischer von Erlach. During the 20th century a pedestrian arcade was built into the place where the constitutional and administrative court now has its seat.

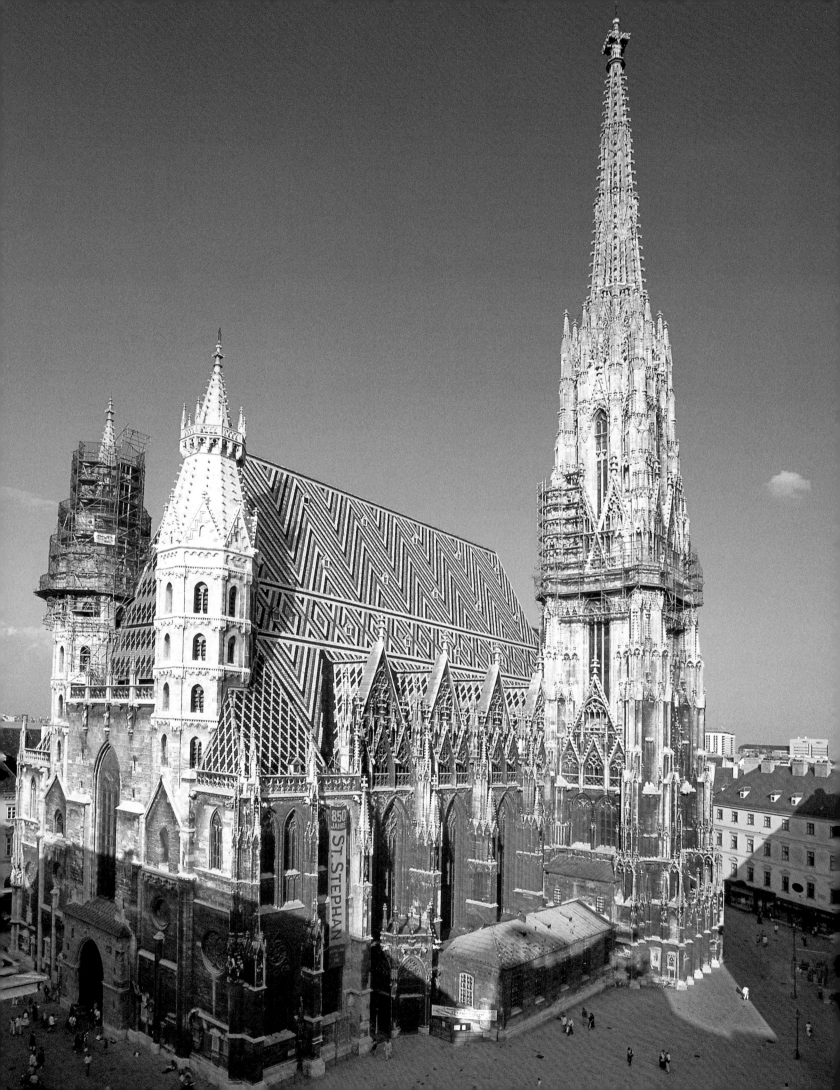

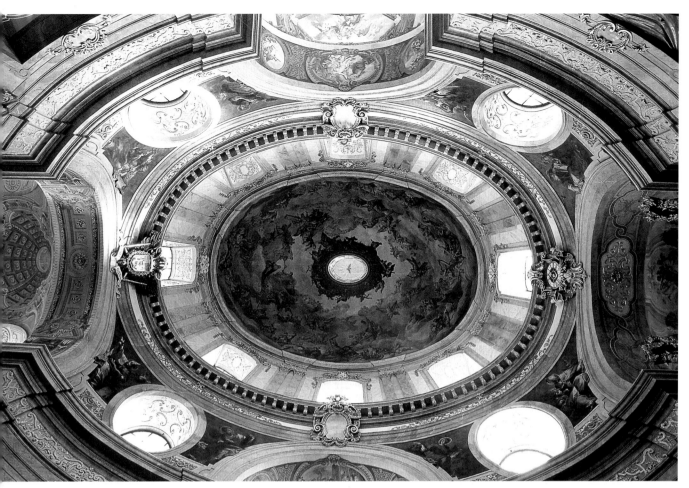

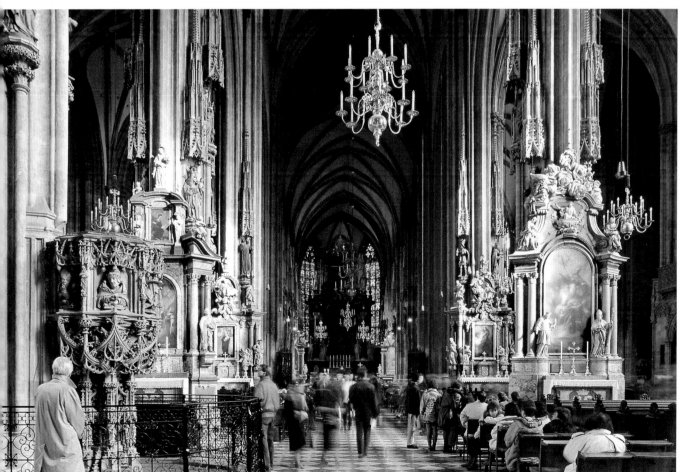

Left page:
The cathedral and metropolitan church of St Stephan is Vienna's most famous landmark and Austria's number one Gothic edifice. It positively dominates the skyline of the old town with its huge steeple and roof colourfully decked with hundreds of thousands of glazed tiles.

The baroque Peterskirche was modelled on its namesake, St Peter's, in Rome. The mighty dome of the central-plan building sports a fresco by Johann Michael Rottmayr. History claims that the present place of worship is built on the foundations of both a late Roman basilica and of a church founded by Emperor Charlemagne in c. 792.

Eight centuries of building have left their mark on Vienna's cathedral. The enormous portal is a legacy of the Romanesque; the lofty nave is lined with Gothic pillars. The latter climaxes in a richly ornamental sandstone pulpit from the late Gothic period.

In 1894 Otto Wagner built the Ankerhaus on Spiegelgasse, finishing it with an elegant glass penthouse. The glass facades set in front of the supporting pillars of the two lower floors were a novelty at the time.

Right page:
Looking from the steeple of St Stephen's at the Haas-Haus opposite you see both the cathedral and the world below mirrored in its glass front. During the age of Historicism August Sicard von Sicardsburg and Eduard van der Nüll erected the Philipp Haas carpet store here, the 1950s successor of which was replaced by the present structure in 1990.

Page 26/27:
There are good views of the inner city and dome of St Michael's from the tower of the Rathaus. The Salvatorian establishment was once the parish church of the royal court. The bones of its former congregation line the walls and floors of the crypt.

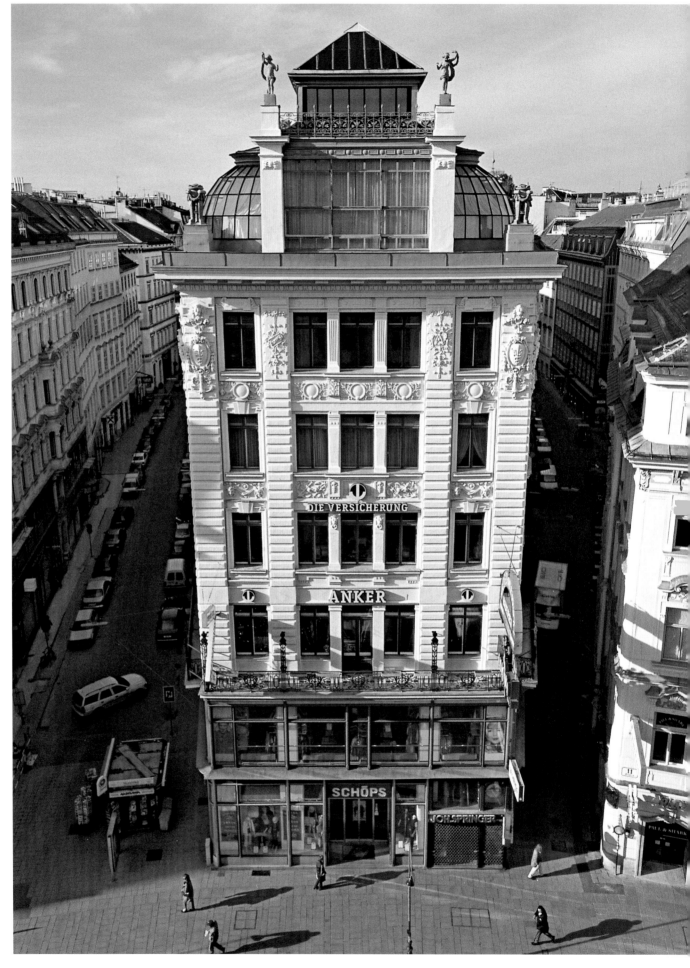

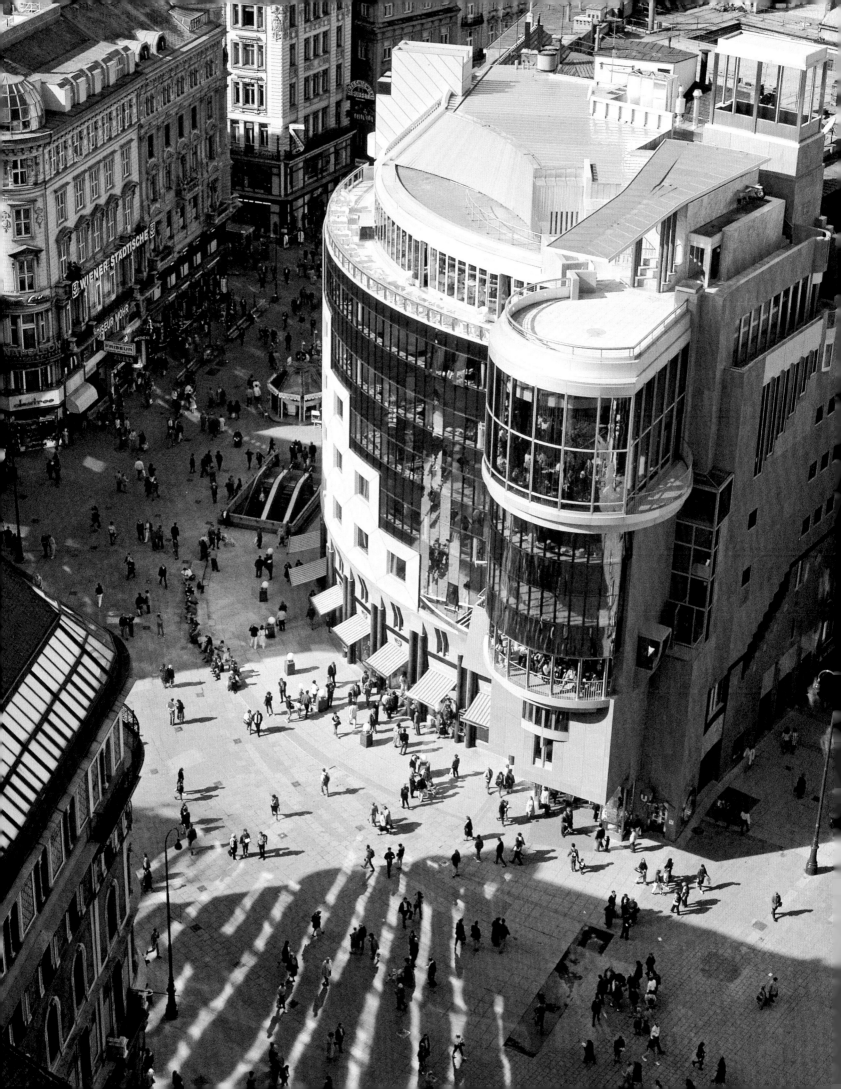

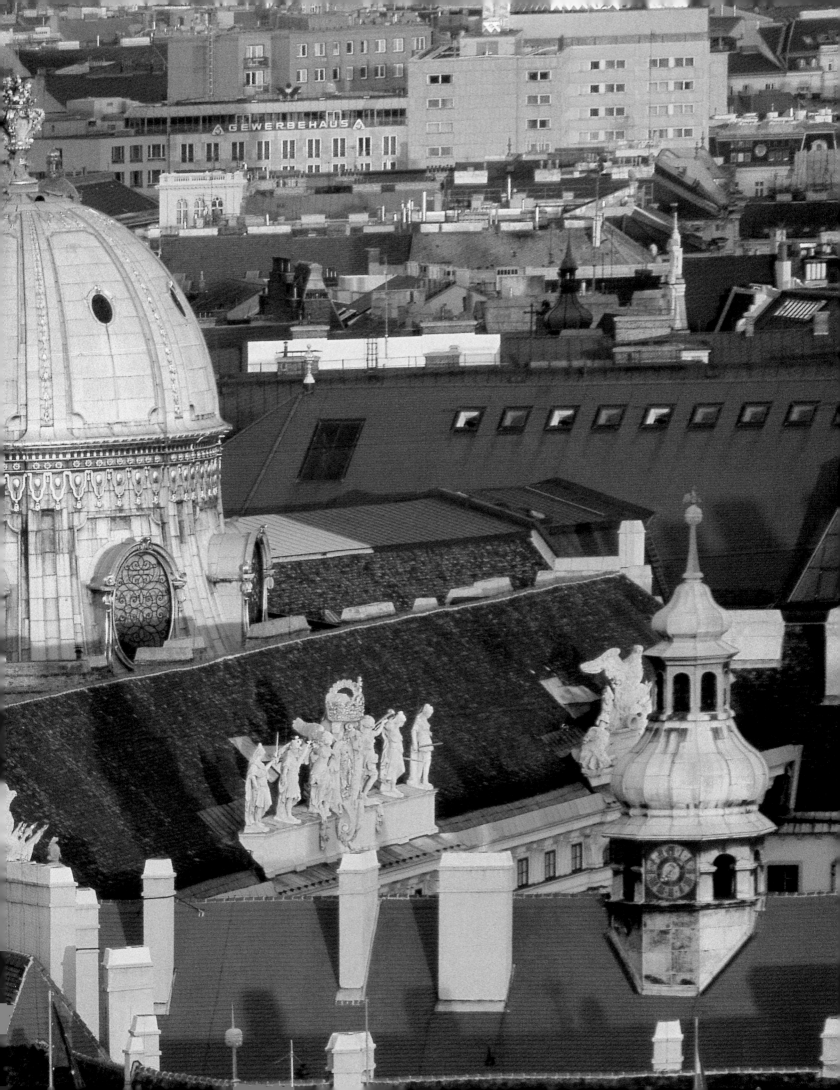

Studying the collection of arms at the Kunsthistorisches Museum (museum of art history) it's quite evident that the building of the Habsburg empire was not always a peaceful undertaking. Over the years the military section of the museum has evolved around the collection of armour accumulated by Ferdinand of Tirol.

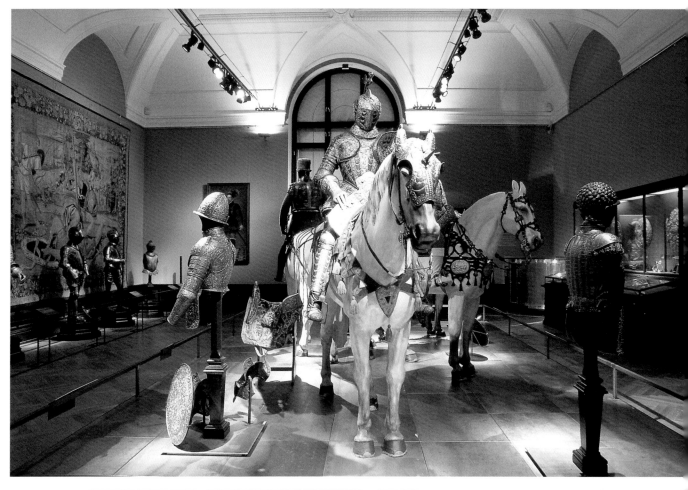

In the Capuchin church, with its frugal interior befitting the mendicant order who once worshipped here, one of Vienna's most popular sights can be found. The Kapuzinergruft is where almost all of Austria's rulers have been laid to rest since 1633 – minus entrails (in St Stephen's Cathedral) and heart (in the Augustinerkirche).

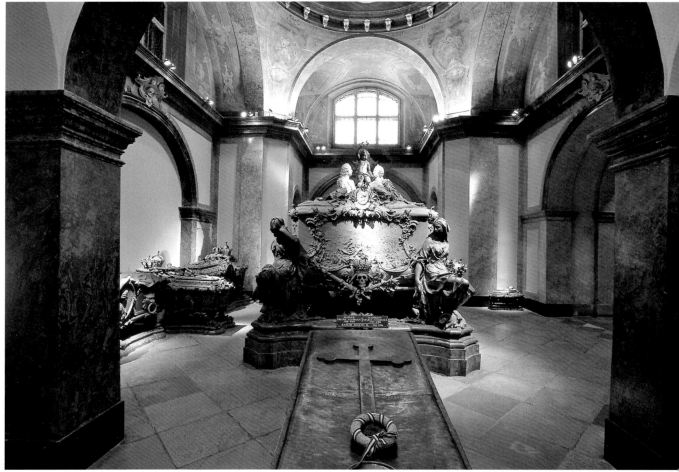

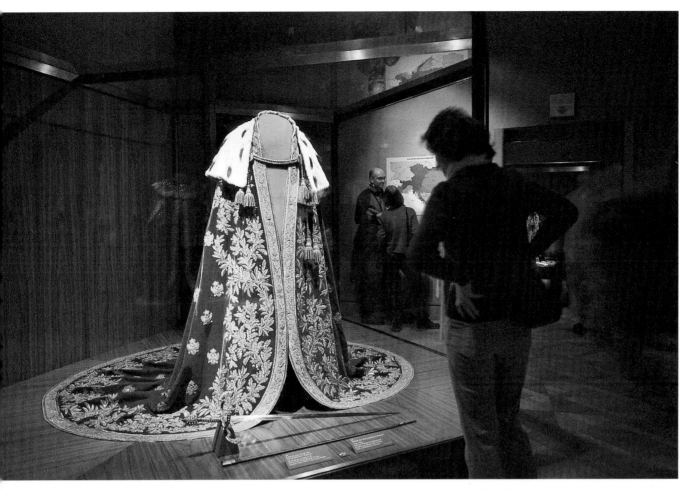

One of the artefacts not to be missed in the treasury is the cloak of the Austrian emperor. The treasury is in the oldest part of the Hofburg or royal palace, which dates back to the 13th century and where the treasure of Burgundy from the 15th century and the treasure of the Order of the Golden Fleece can also be marvelled at.

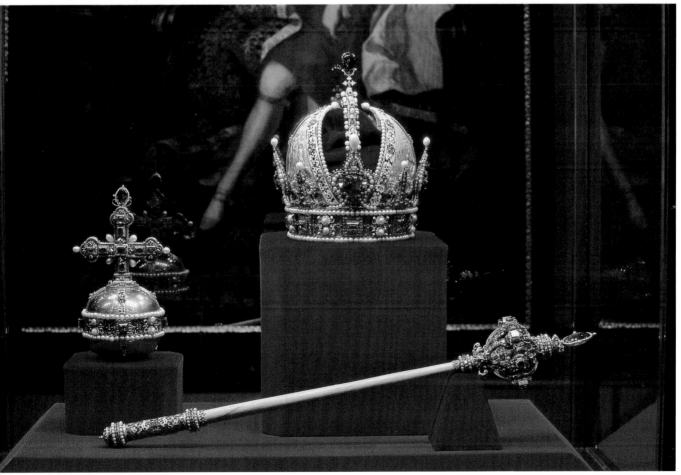

For centuries the orb and sceptre were the symbols of power and dignity wielded by the monarchs of the Habsburg dynasty. They are now on display in the treasury alongside the crown of Emperor Rudolf II (1552–1612). The entrance is on Schweizerhof, named after the Swiss guard once posted here.

Page 30/31:
The Neue Burg on Helden-platz – only completed after the fall of the monarchy – with the Karlskirche beyond it. Vienna's main baroque sacred building was designed by father and son Fischer von Erlach. The church was founded to commemorate the year of the plague in 1713 by Emperor Karl VI and dedicated to the patron saint of the epidemic, St Charles Borromeo.

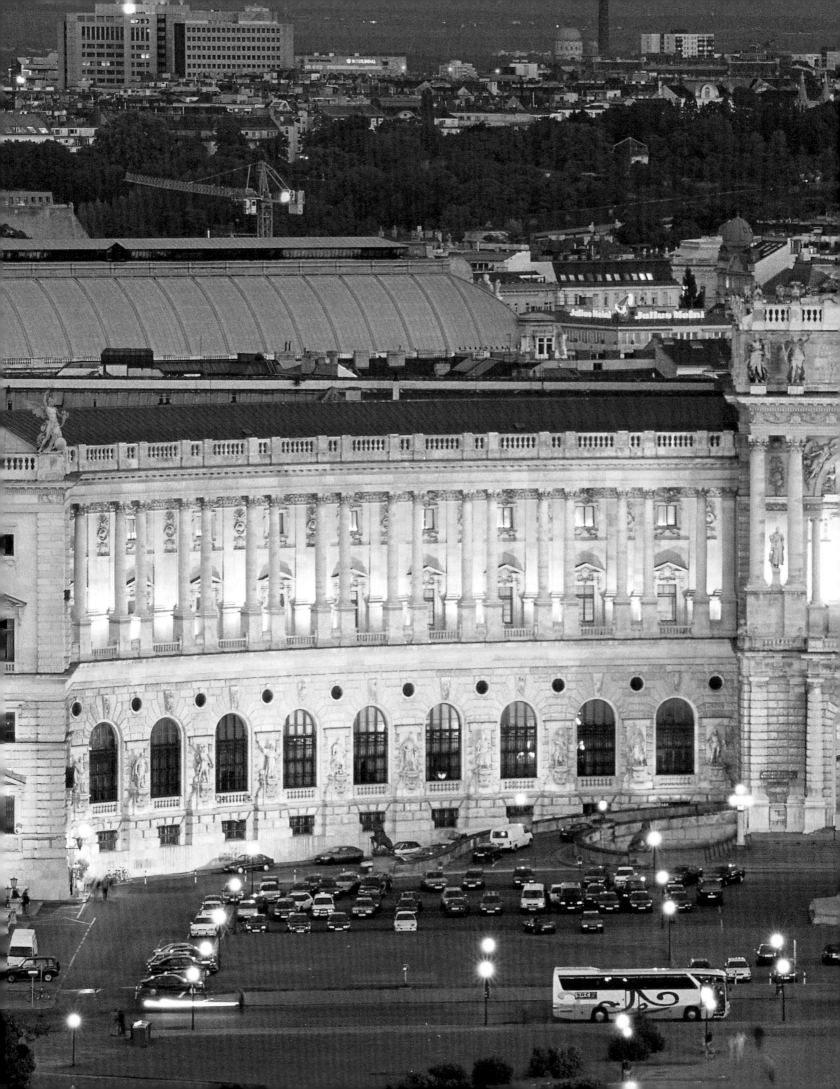

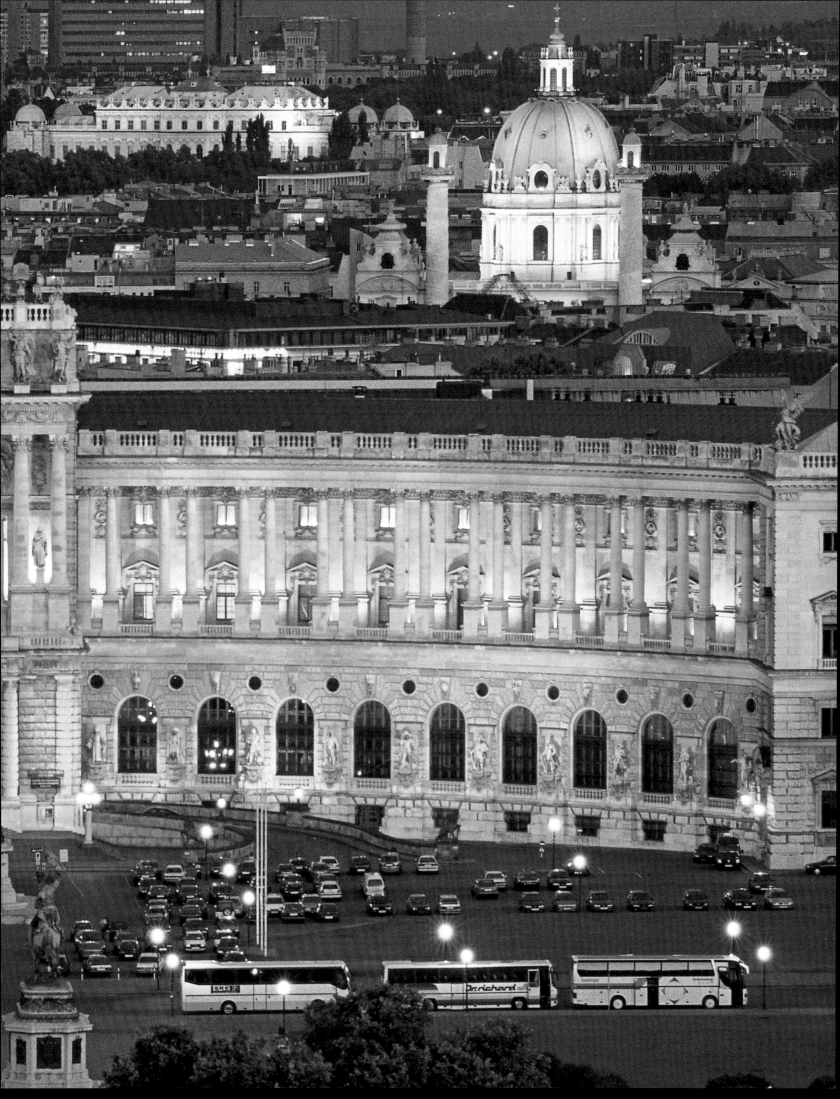

One of the largest collections of graphic art in the world is on display at the Albertina in the Palais Erzherzog Albrecht. The museum is the first worldwide to have a fully-automated storage system. The "flying roof" spanning the entrance was long a bone of contention and built by the Austrian company Waagner Biro who also worked on the glass dome of the Berlin Reichstag.

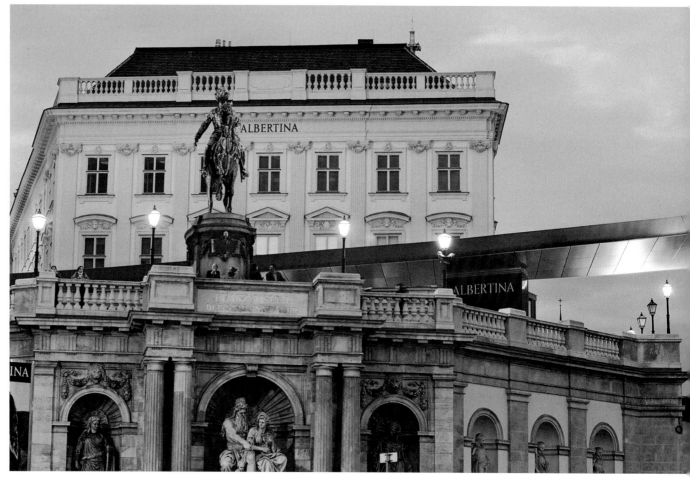

Right:
Louis de Montoyer fashioned the Habsburg rooms of state in the Albertina in the French Imperial style under Duke Albert von Sachsen-Teschen. The rooms form an enfilade which runs parallel to the Burggarten, the most famous bit of which is the Musensaal or hall of the muses, designed for Archduke Carl.

Far right:
Dr Klaus Albrecht Schröder has been director of the Albertina since 1999. As the author and editor of numerous publications on art history he is not only respectful of tradition but also aware of the modern requirements of a 21st-century museum. He aims to secure a successful future for the collection which was founded by Duke Albert von Sachsen-Teschen.

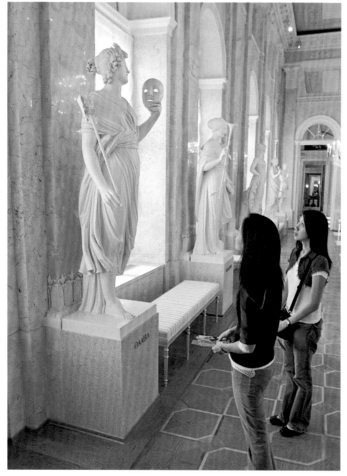
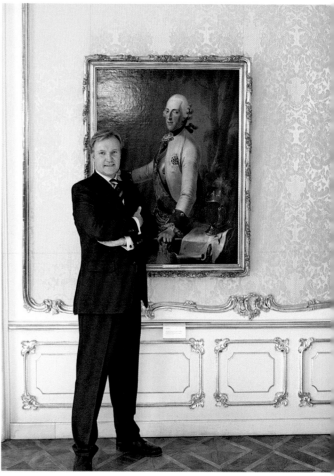

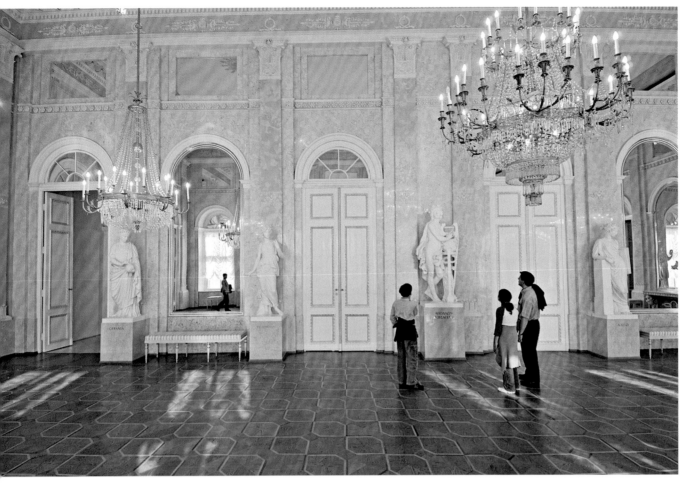

The Musensaal in the
Albertina was designed by
Josef Kornhäusel. The
famous neoclassical sculp-
tor Joseph Klieber carved
the Apollo and the Nine
Muses cycle which gives
the room its name. Up
until 1919 the Musensaal
was used by the Habsburgs
as a dining room and ball-
room.

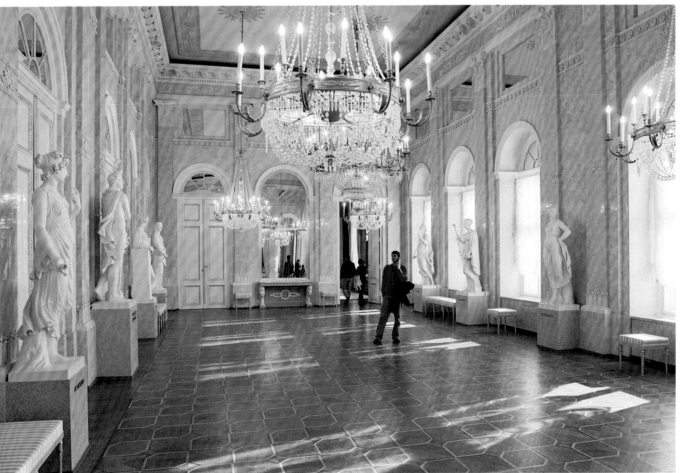

Josef Kornhäusel was also
entrusted with the rebuild-
ing of the Schottenstift
or Scottish monastery.
Depicted in the Vatican in
Raphael's Parnassus, the
nine Muses of epic poetry,
lyric poetry, comedy,
history, music, astronomy,
tragedy, geometry and
song and dance also adorn
the Albertina.

The Austriabrunnen on Freyung is a personification of Austria herself. The Schottenstift behind it founded by Heinrich Jasomirgott II in 1155 gets its name from the monks who once resided here; they were from Ireland or Scotia Major (Latin Scotia = German Schottland). The altar from 1470 in the monastery museum is an important historical source as it depicts the city of Vienna during the 15th century.

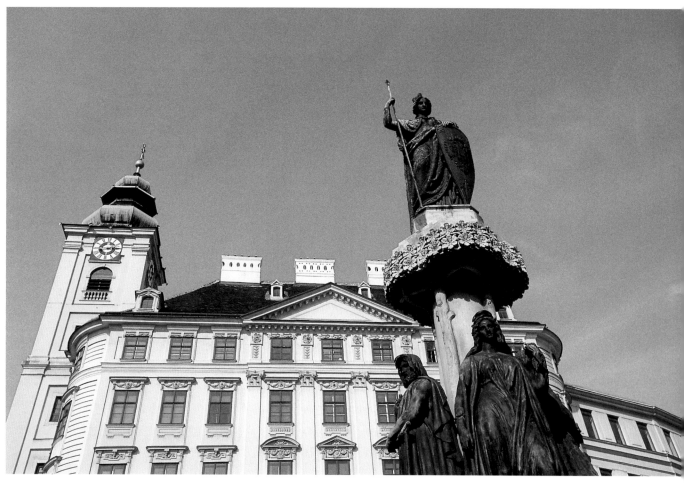

The Palais Daun-Kinsky on Freyung is one of the most important palaces of the high baroque in the centre of Vienna. It was built by Lucas von Hildebrandt between 1713 and 1719 for Field Marshal Count Wirich Philipp Daun. It was passed on to Countess Rosa von Kinsky via Count Khevenhüller in 1784.

Right page:
The Palais Daun-Kinsky, complete with its magnificent staircase, is now under the ownership of Karl Wlaschek. The founder of the cheap supermarket chain Billa is thought to be the richest man in Austria. The real estate giant has earmarked the palace for later use as his own private mausoleum.

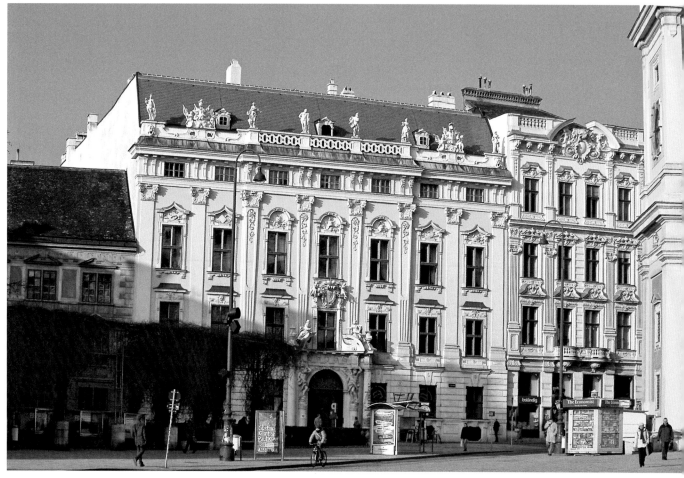

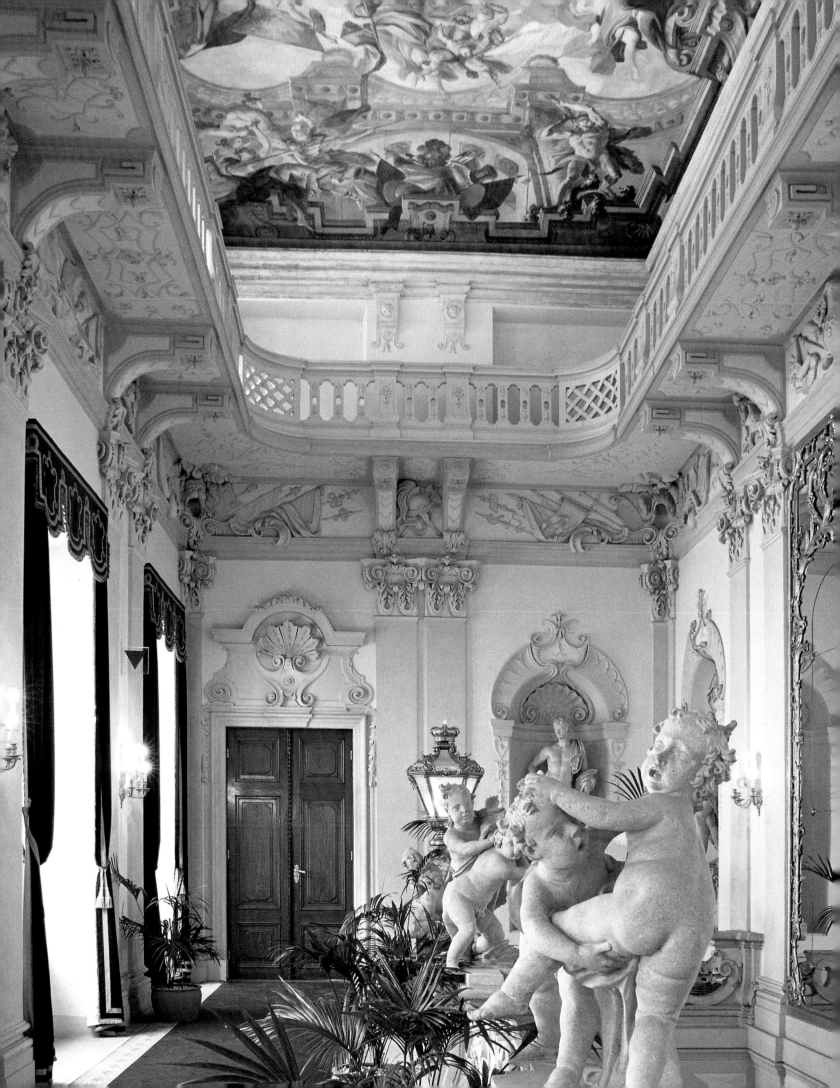

Café Landtmann next to the Burgtheater was opened before its neighbour in 1873. On its refurbishment in 1929 its now famous wooden pillars were added to the entrance which depict scenes from various theatre premieres. Actors still frequent the café, as do politicians and, of course, the many visitors to the city.

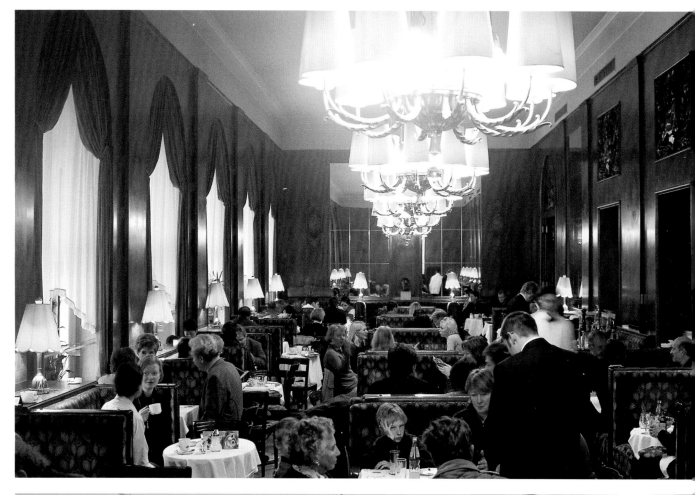

Café Museum on Operngasse rapidly became a popular meeting place for the artists of Vienna. Its regular clientele has included Elias Canetti, Karl Kraus, Franz Lehar, Georg Trakl and Franz Werfel. From here it's not far to Naschmarkt, Karlsplatz and the Secession building.

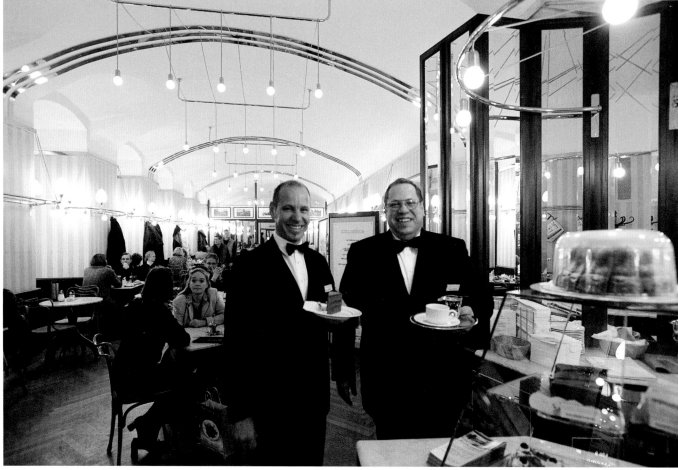

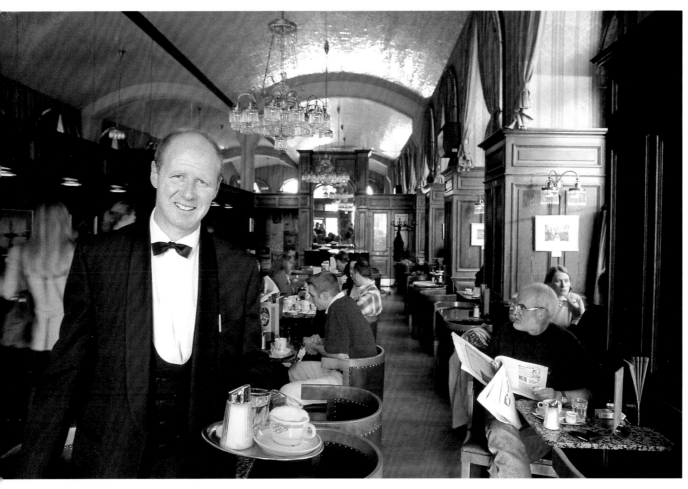

Waiter Erwin Wagner in his smart tails is obviously very proud of the long tradition of Café Schwarzenberg on Kärntner Ring. One of its most famous punters was architect Josef Hoffmann, one of the founders of the Wiener Werkstätte, who dreamt up many of his designs here. The coffee house still has its original interior dating back to the end of the 19th century.

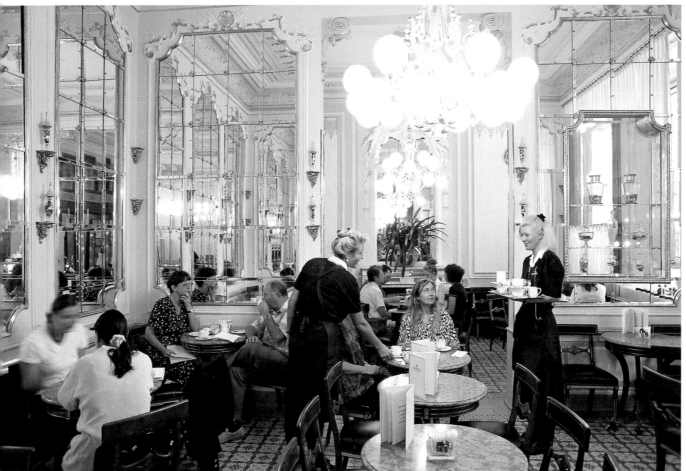

The imperial and royal confectioner's Demel on Kohlmarkt was set up by Ludwig Dehne from Württemberg and later passed on to an assistant called Christoph Demel, after whom the café is still named. The café is famous for its ongoing battle with Hotel Sacher for the rights to call the Sachertorte their own; Demel was allegedly the first to perfect the gooey chocolate gateau. Demel's candied violets were also once a hot favourite with the Empress Elisabeth.

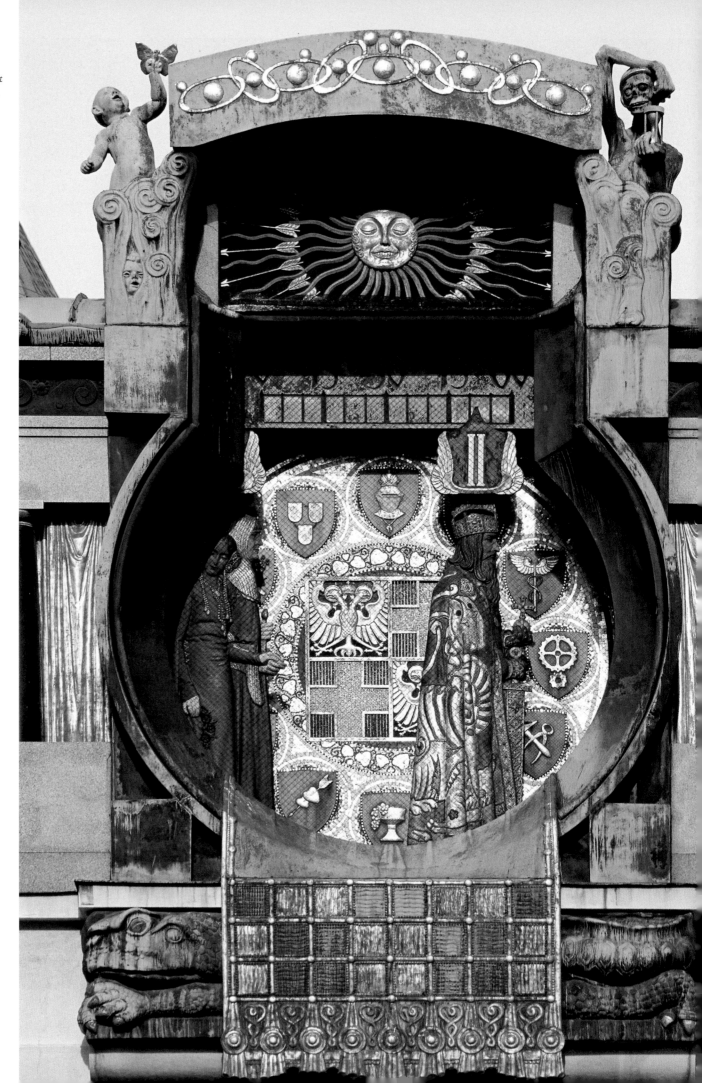

The Ankeruhr on Hoher
Markt was made from
designs by Jugendstil artist
Franz Matsch. The clock
depicts twelve famous
Viennese personalities on
its hourly chimes. Mayor
Johann Andreas von
Liebenberg is presented
to the dulcet tones of the
Austrian folk song
Oh, du lieber Augustin.

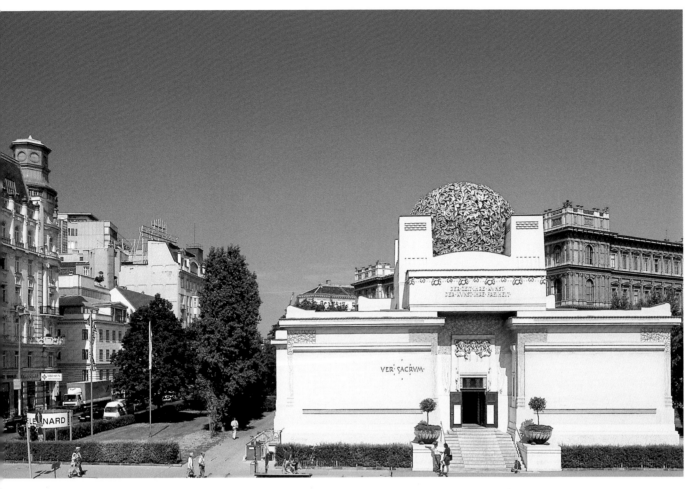

The Secession building is crowned by a dome of gilded bronze laurel. Josef Olbrich completed the exhibition hall in 1898 where the work of the then young artists' association was to be displayed. Today the Secession houses what remains of Gustav Klimt's impressive Beethoven frieze.

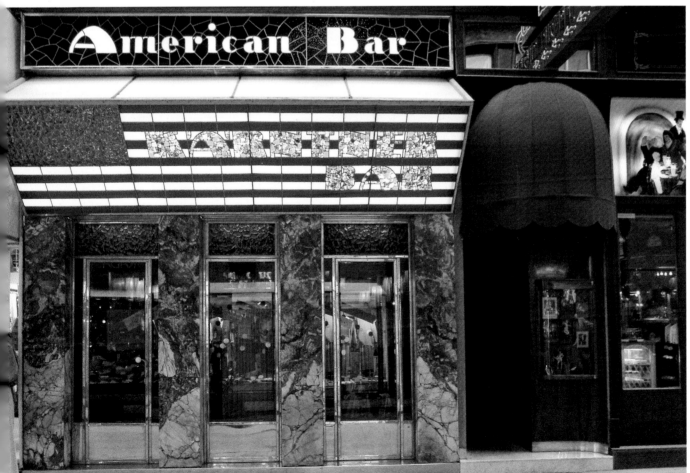

The American Bar on Kärntner Durchgang is one of the earliest examples of the architectural Modern Style in Vienna. It was built by Adolf Loos whose experience of turn-of-the-century America is clearly evident in his design. The tiny bar, its proportions artificially enlarged by cleverly placed mirrors, is now a listed building.

The shop interior of imperial and royal suppliers Knize is also by Adolf Loos and has remained unaltered to the present day. The gentlemen's out-fitters is heralded as the founder of the first men's fashion label in the world and can boast crowned heads and international stars among its clientele. Oskar Kokoschka paid for his suits with paintings and even Marlene Dietrich had frock coats cut here for her stage shows.

Right page:
On Kärntnerstraße, one of the best-known shopping promenades in Vienna, is the world-famous glassware store J & L Lobmeyr. In collaboration with Thomas Alva Edison, imperial and royal suppliers Lobmeyr were the first to illuminate their showrooms with elec-tric lights in 1882. The building has been under family ownership for almost 200 years; its glassware, marked with the famous family signet, fetches high prices at auction.

Rudolf Scheer & Söhne were not only suppliers to the imperial and royal household; the emperor of Germany and other regents also bestowed the title of "royal shoemaker" upon the establishment on Bräunerstraße. The family business has an eye to tradition but is also very up to date; Markus Scheer recently developed a range of shoe care prod-ucts which comes with an accompanying CD-ROM.

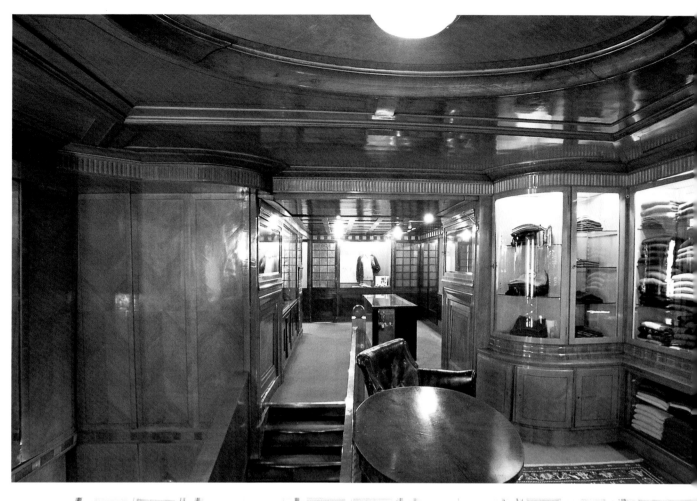

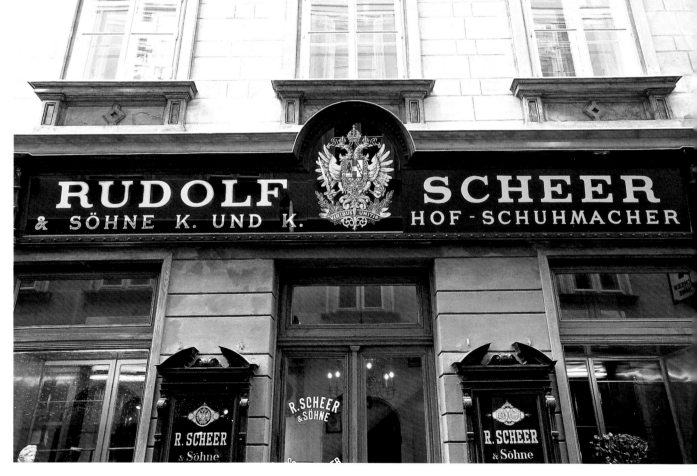

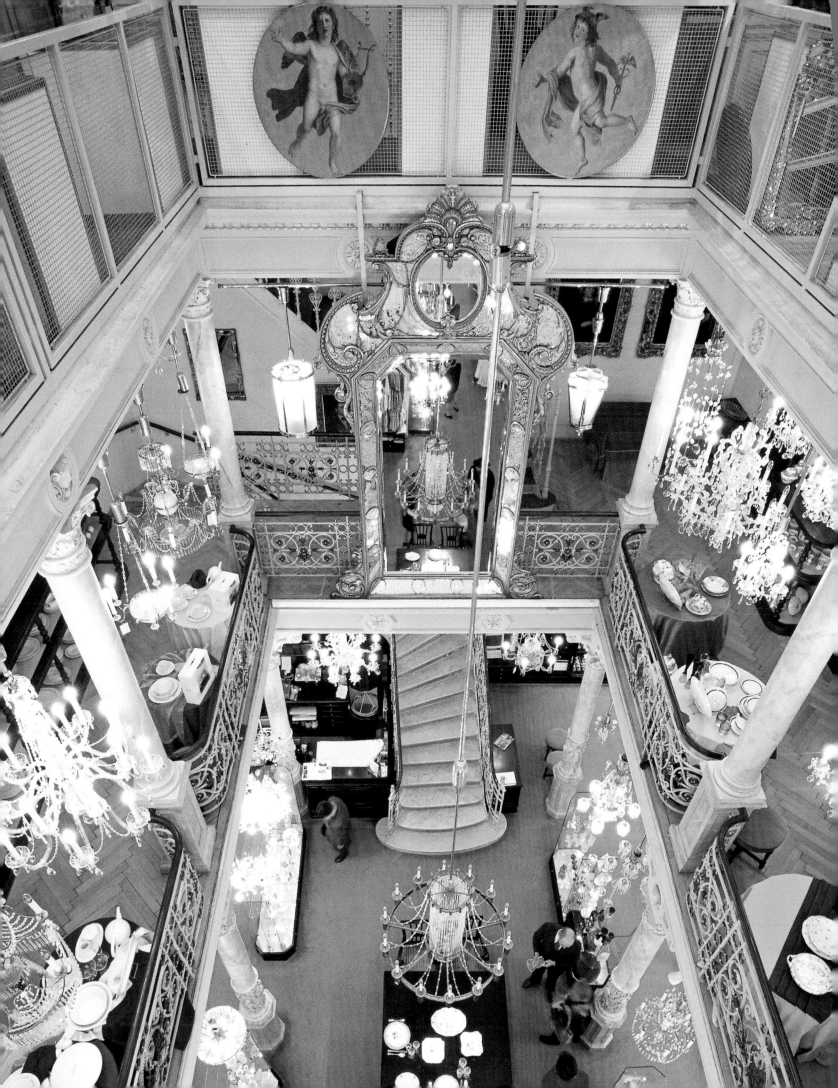

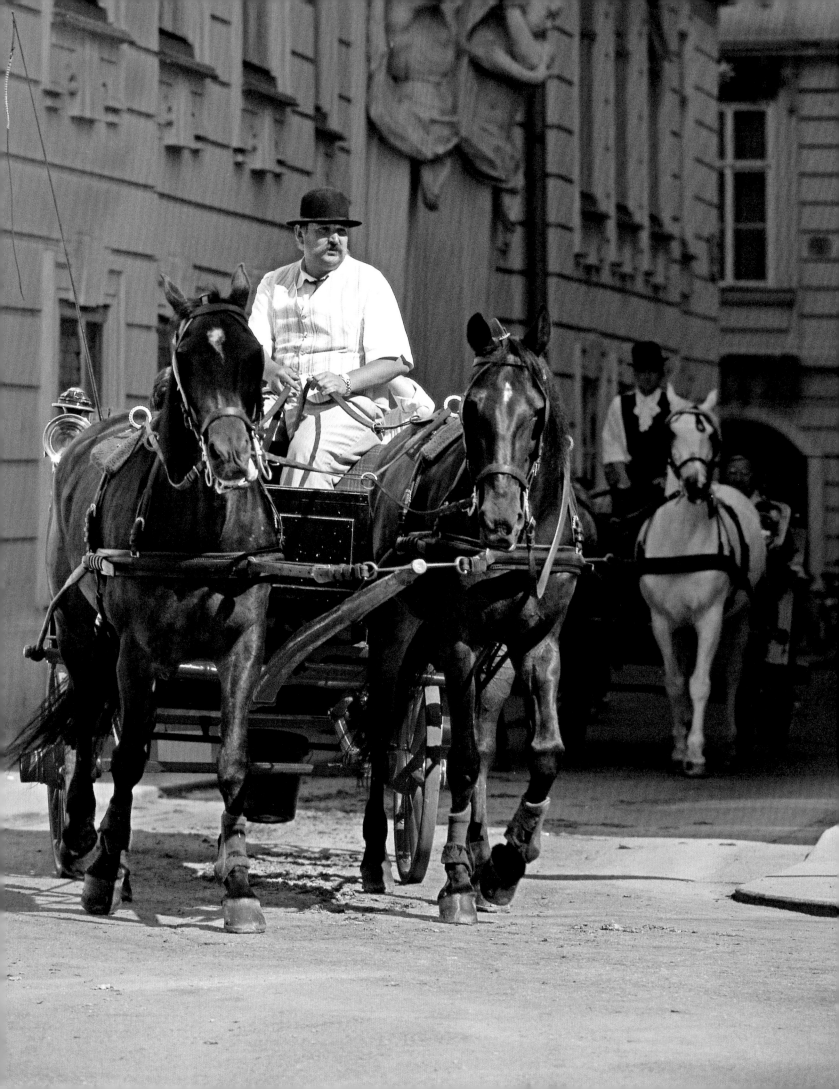

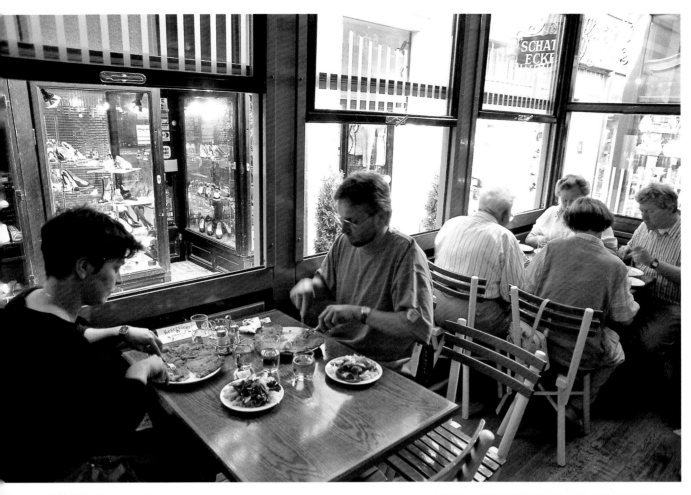

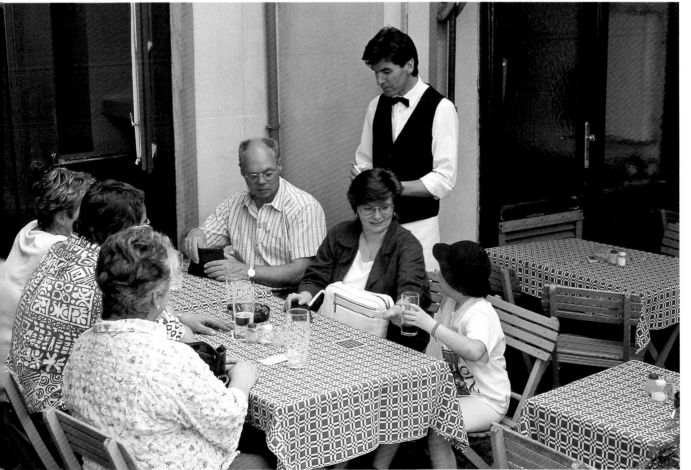

Left page:
The famous horse-drawn carriages, also known locally as Zeugl, have been in operation here since the end of the 17th century. On Veronikagasse in the 17th district there is a museum of engravings, models and photographs dedicated to Vienna's age-old profession.

The cosy Figlmüller Beisl or pub in the heart of town has served the likes of Leonard Bernstein and Bud Spencer in its time. It is particularly revered for its wafer-thin Wiener Schnitzel which usually entirely hides the plate. Their success has prompted the proprietors to open two more taverns in a similar vein, one of them in Grinzing.

Zu den drei Hacken is another popular Beisl in the centre of Vienna. In the nooks and crannies of this traditional tavern Viennese cuisine is presented as it was a hundred years ago. And if you're not sure what Beuschel are, just ask one of the attentive yet discrete waiters …

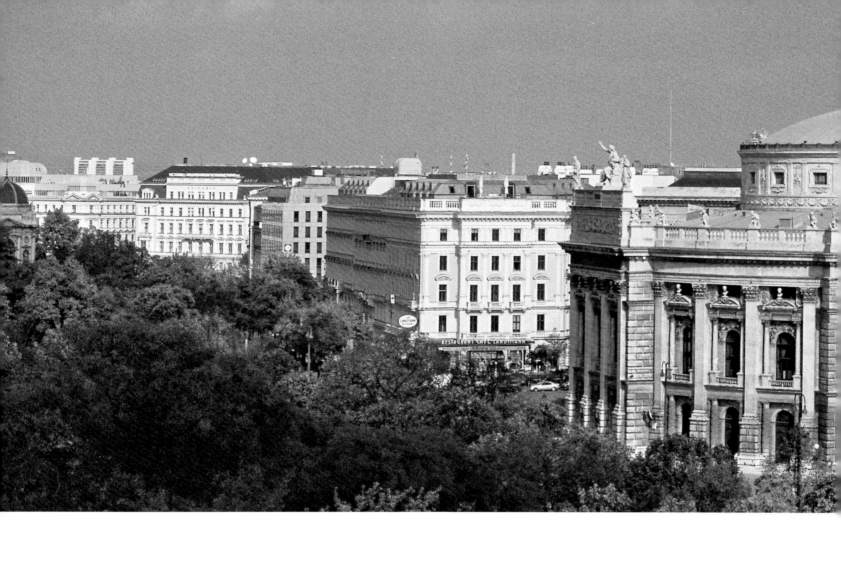

Going imperial and royal on Ringstrasse

The magnificent Ring boulevard, as Ringstraße is known to the Viennese, was laid out under Emperor Joseph I in the second half of the 19th century. Bastions and defences were torn down to make way for palaces and stately homes in what is termed Vienna's *Ringstraßenstil* or style of Ringstraße.

The Historicist pomp and grandeur of the buildings lining the Ring is not everybody's cup of tea. Twin museums front the ensemble on Burgring opposite the royal palace of the Hofburg. The Kunsthistorisches Museum contai[ns] one of the most famous collections of art in the wor[ld] and the Naturhistorisches Museum is home to the ma[ny] natural history specimens collected by Emperor Franz and made accessible to the public by his wife Mar[ia] Theresa in 1765.

The Habsburgs' love of art is also evident in a gener[al] Viennese enthusiasm for the theatre. The Burgtheater [is] thus not just one of the most luxurious theatres in th[e] German-speaking countries of Europe but also one [of] the most linguistically famous. Theatrical director Cla[us] Peymann may not have been fluent in the German of th[e] Burgtheater when he took up his post in 1986 but tod[ay] *Burgtheaterdeutsch* has become an accepted mode [of] theatrical speech.

At the Österreichisches Museum für Angewandte Kun[st] (museum of the applied arts) on Stubenring you c[an] marvel not only at the popular coffee house bentwo[od] chairs fashioned by the Thonet brothers but also Jugen[d] stil vases by Josef Hoffmann, one of the founders of th[e] Wiener Werkstätte. The highlight of Gustav Klimt['s] oeuvre, his marvellous Beethoven frieze, is on view [at] the Secession building whose ornate domed roof is ofte[n] mockingly referred to as the "golden cabbage". Anoth[er] formerly gilt edible is even more famous; after th[e] serving of Wiener Schnitzel with gold leaf was forbi[d] den, the golden yellow ersatz of the breadcrumb cru[st] was invented ...

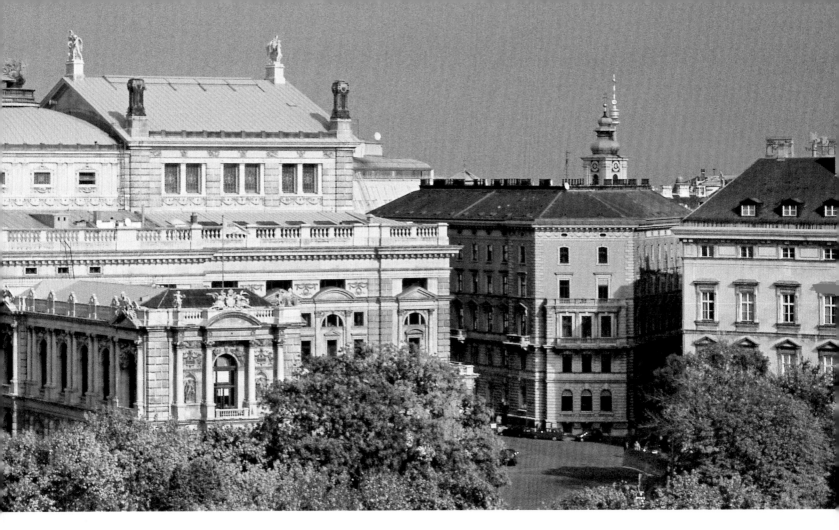

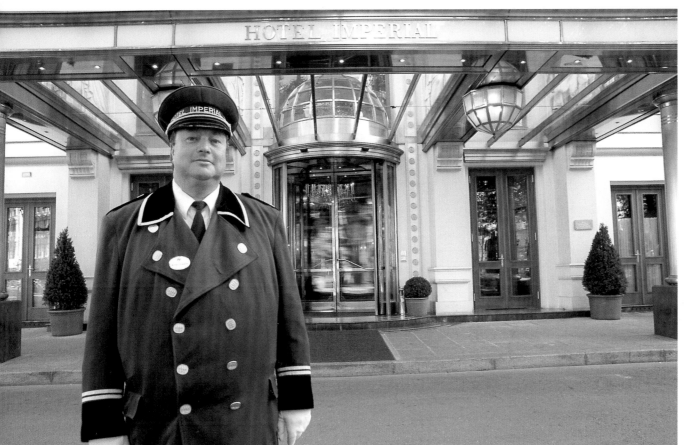

Above:
From the roof of Vienna's parliament there is a marvellous view of the Burgtheater and Dr-Karl-Lueger-Ring with its impressive buildings. The second half of the 19th century saw the reiteration of the architectural fashions of the Romanesque, Gothic, Renaissance and baroque to form an idiosyncratic amalgamation known as Historicism.

Left:
Doorman Wolfgang Hauswirth graciously receives illustrious guests to the Hotel Imperial, one of the most luxurious hostelries in the world. Outmoded forms of address may no longer be in use – but the charm and courtesy of Old Vienna is certainly still very much apparent in the services on offer here.

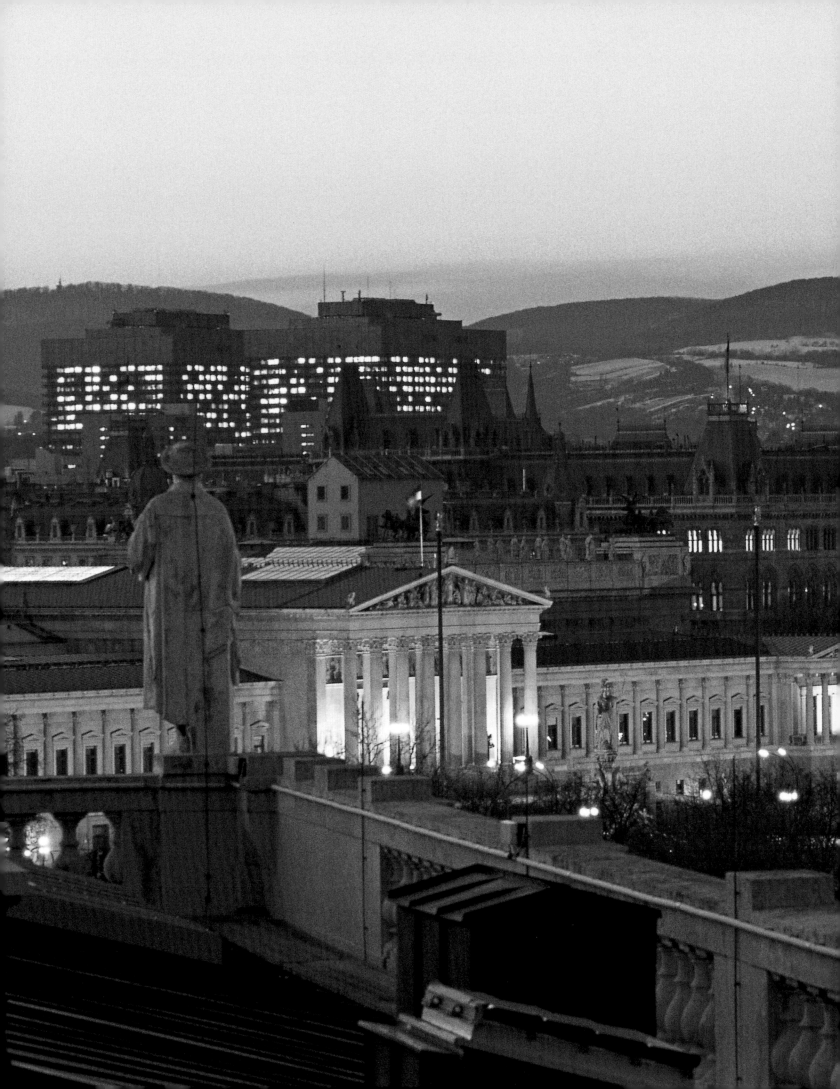

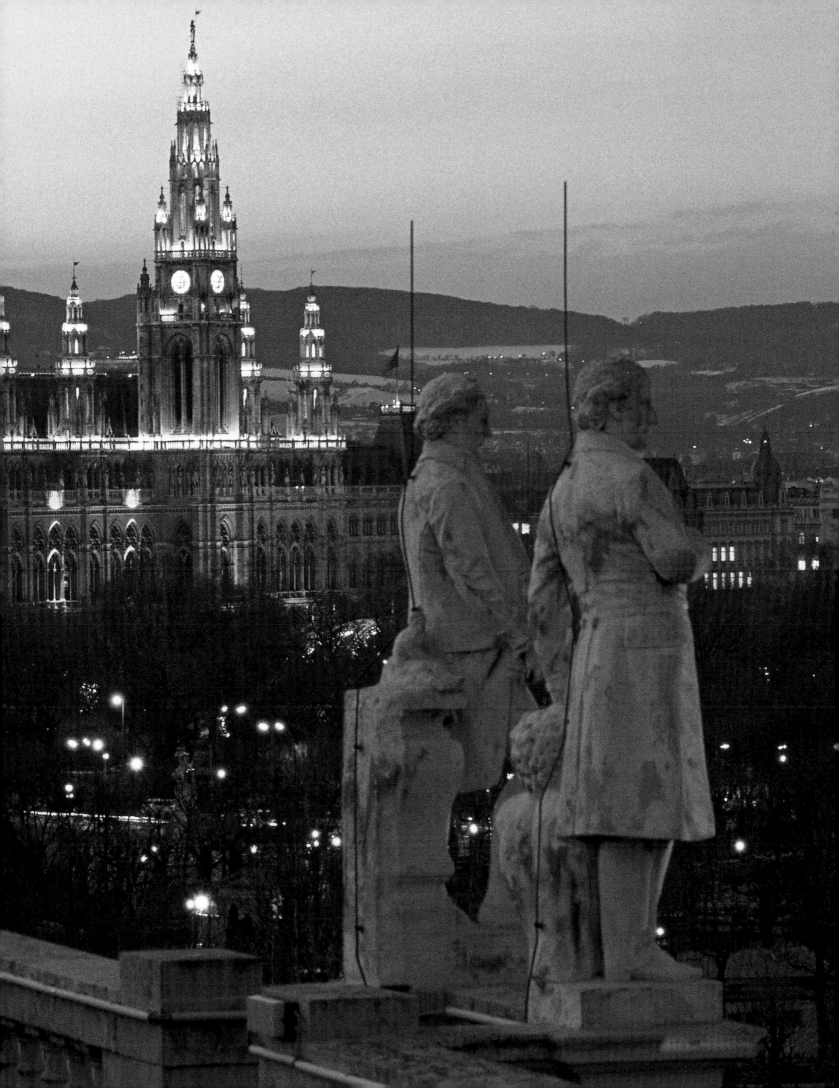

Page 46/47:
The roof of the Kunsthistorisches Museum is a great place from which to gaze out over parliament and the Rathaus. Greece, the cradle of democracy, was the inspiration behind Theophil Hansen's design, within the walls of which Austria's new imperial and regional representatives once held session.

The Burgtheater on Ringstraße is one of the most famous theatres in Europe, not least for its very own brand of Burgtheaterdeutsch which has become standard in many German-speaking theatres. At its previous location on Michaelerplatz plays had to have a happy end by decree of the emperor; contemporary and more critical scenarios are now also tolerated…

From the south staircase of the Burgtheater you can see from the boxes in the circle to the doors of the entrance, through which theatre-goers pour in their hundreds. 80% of all tickets are sold – a percentage most theatres can only dream of. It's also the dream of any self-respecting actor or actress to tread these revered boards.

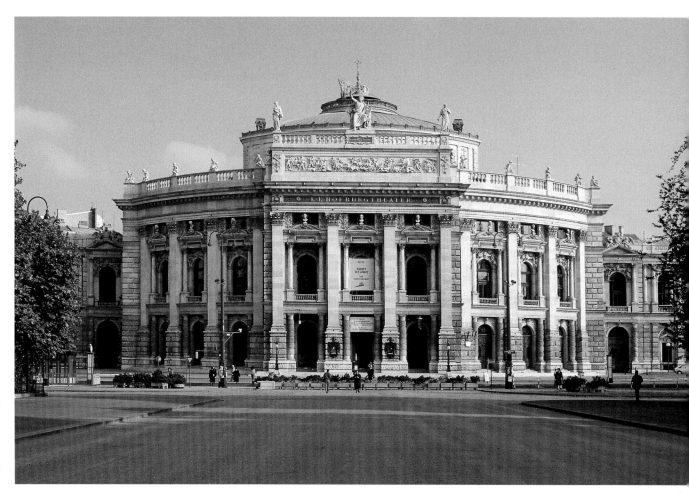

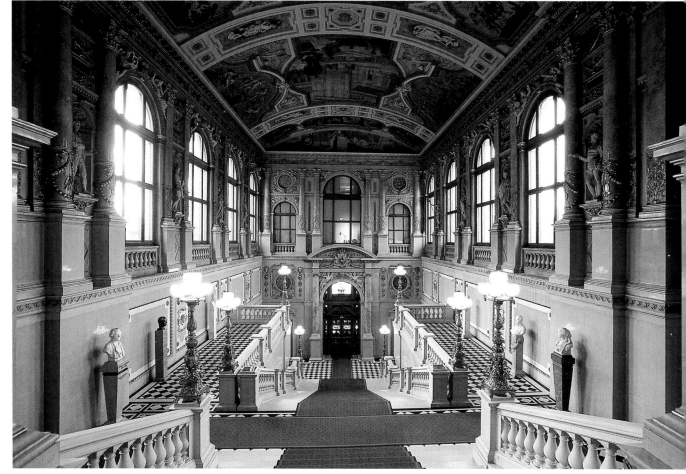

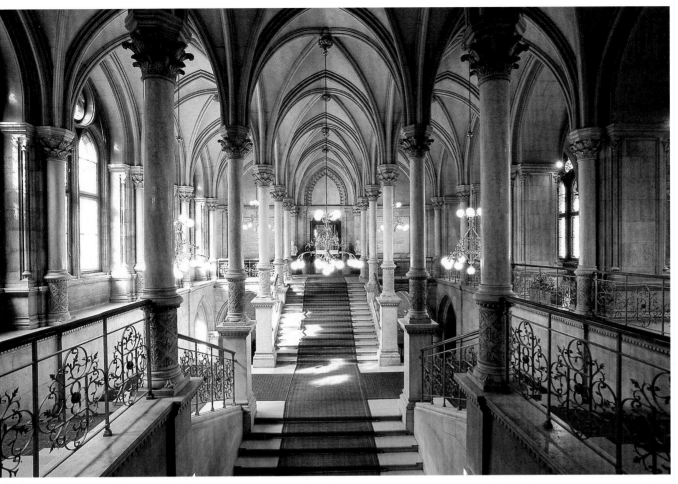

The ballroom of the Rathaus is approached via a grand staircase. The building was erected by Friedrich von Schmidt who based his plans on baroque palaces and included no less than seven courtyards. The interior is no less expansive, with 1,575 rooms lit by 2,035 windows.

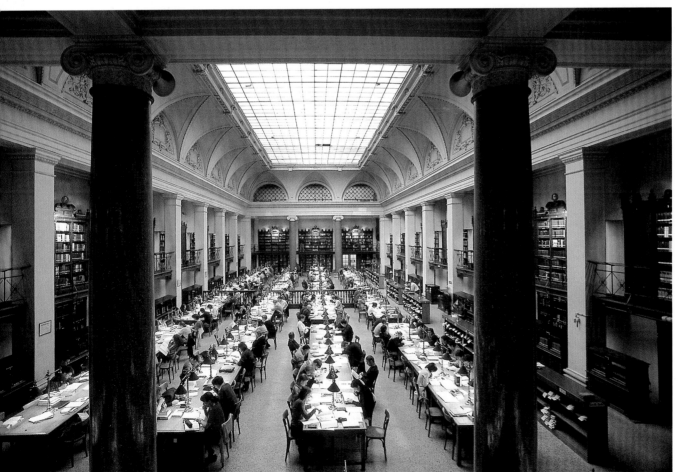

As early as 1365 Duke Rudolf IV began planning a public library. With over 6.5 million volumes Vienna's university library is the largest scholarly library in Austria. The institution is still very public spirited; you don't even need a library card to study in the reading room.

Page 50/51:
The Jungbürgerball or junior ball takes place in the festive ballroom of the Rathaus, recently lavishly restored. The statues lining its walls include such historic figures as Duke Albert von Sachsen-Teschen. The town hall is the seat of Vienna's mayor and local council.

49

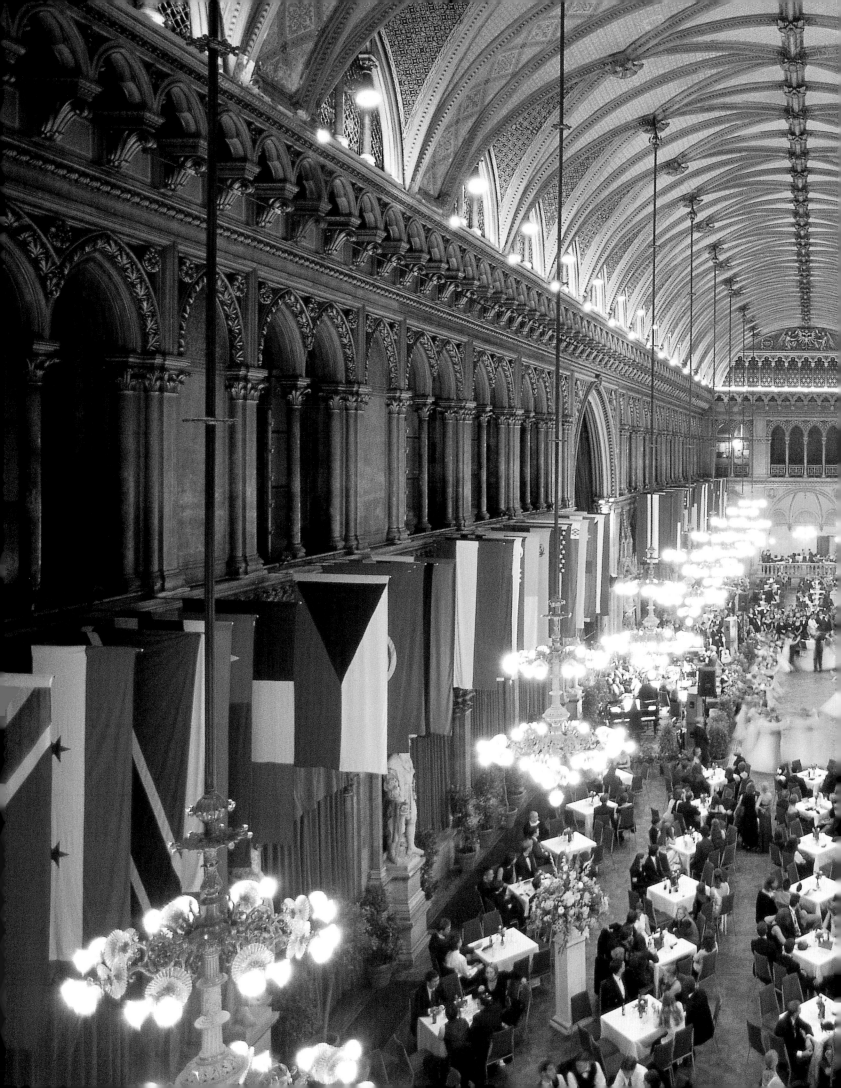

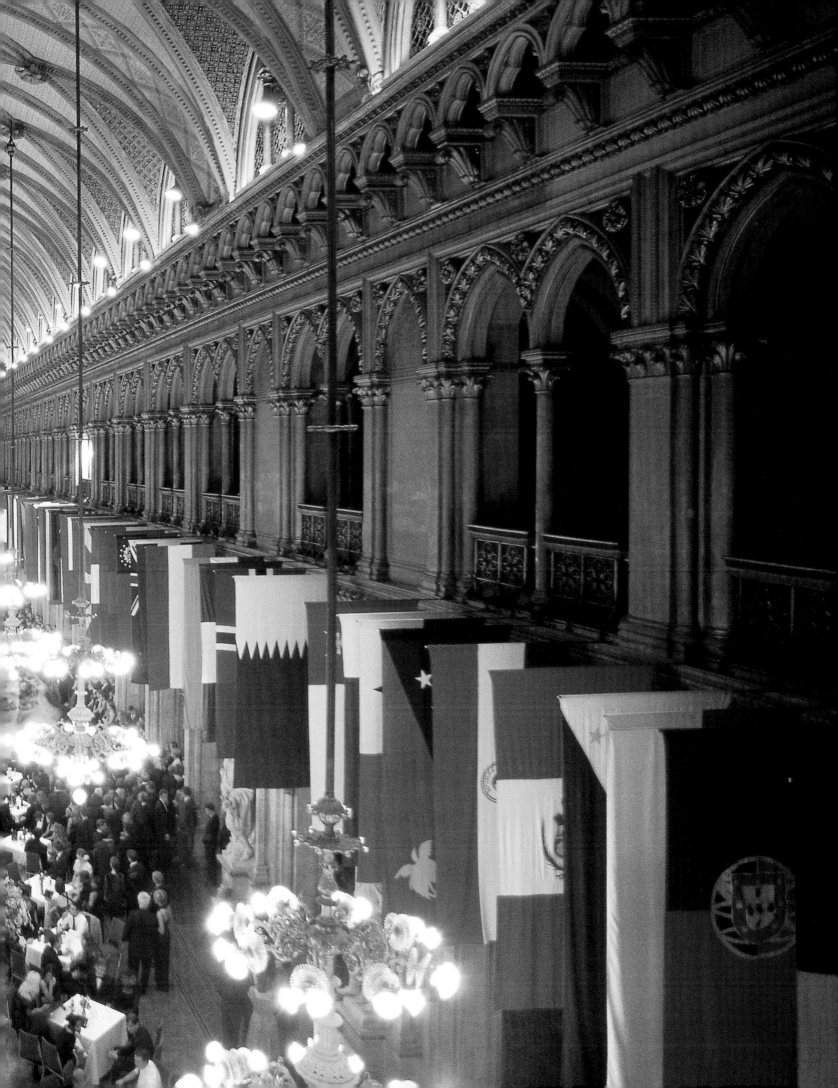

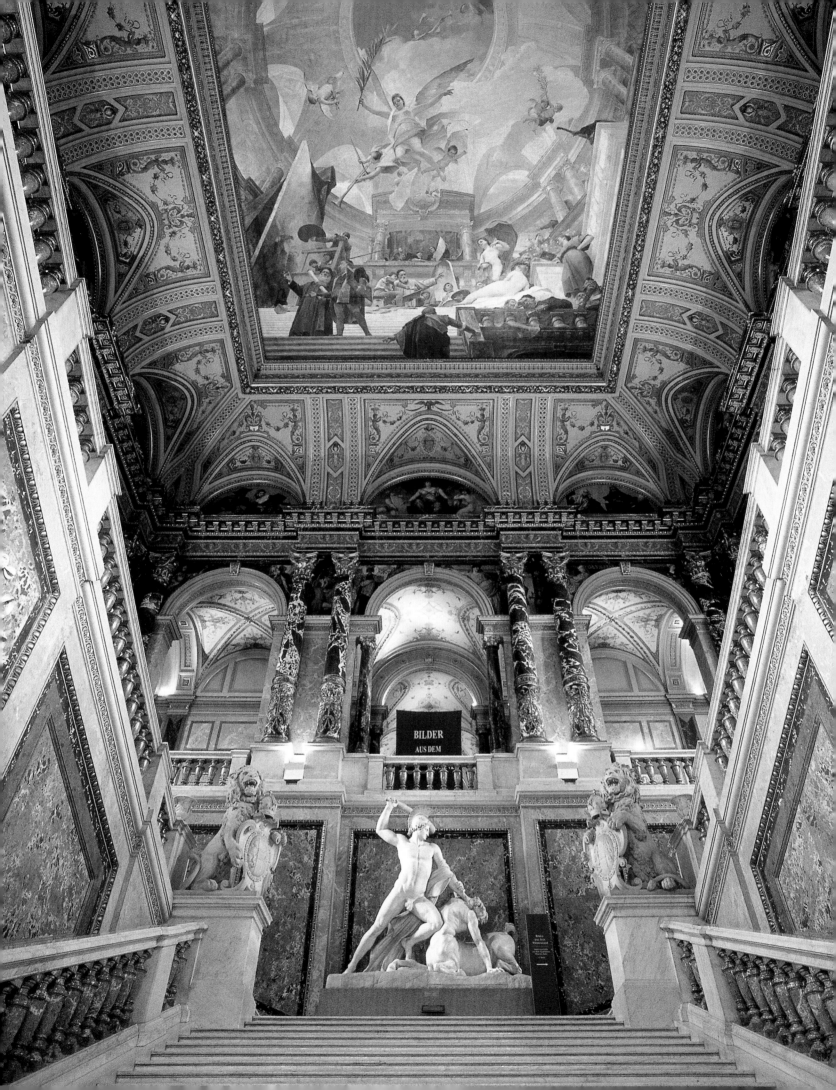

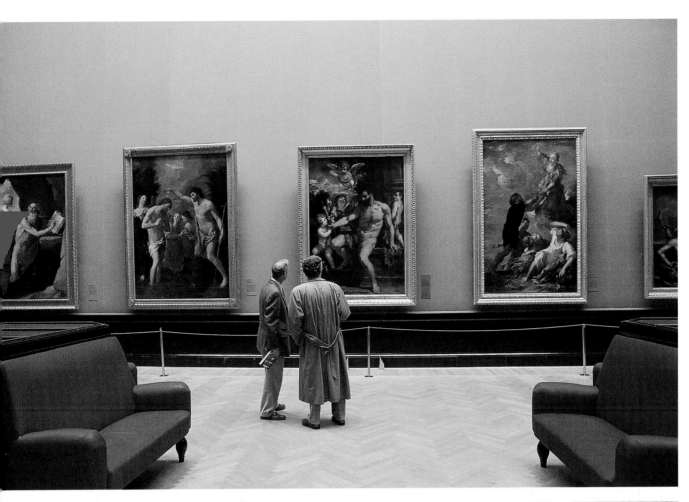

Left page:
The fresco on the stairs of the Kunsthistorisches Museum is by Mihály Munkácsy. The Hungarian was originally from a Bavarian family and changed his name Michael von Lieb to the former out of love for his native town of Munkács. Many of his works are now on show at museums in Budapest, Munich and the USA.

The world-famous art collection at the Kunsthistorisches Museum fills 15 halls and 24 smaller galleries. Room VI has Italian masters on display. The base stock of the exhibition was compiled by Archduke Leopold Wilhelm, a passionate collector of art.

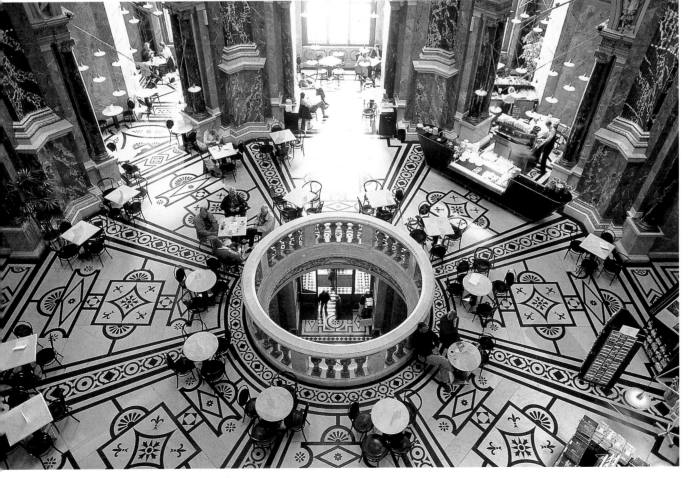

The splendid and richly ornamental domed hall of the Kunsthistorisches Museum houses a grand café on the first floor. The building was opened in 1891 together with its twin, the Naturhistorisches Museum, which is devoted to natural history. It has long been one of the major museums of art worldwide.

In the days of yore the emperor had his own imperial box at the Staatsoper. Time has since moved on; the state opera now puts on special shows for children and its often controversial prommers (who stand for the duration) are also legendary. The world-famous Opernball is also held here, patronised chiefly by well-dressed VIPs from the world of commerce and politics.

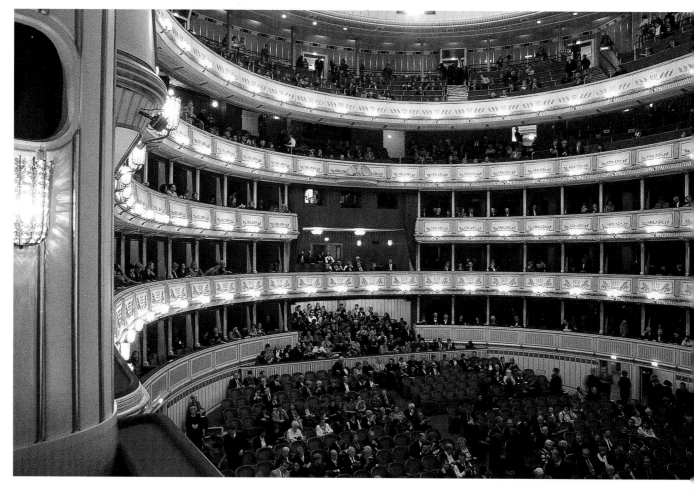

The excellent acoustics of the Goldener Saal at the Musikvereinsgebäude (Society of Friends of Music) in Vienna makes it the best concert hall in the world. Architect Theophil Hansen had to rely on his intuition when building it as acoustics only became the subject of scientific research during the 20th century. One of its most famous events is the New Year's Day concert given by the Vienna Philharmonic.

Right page:
The Staatsoper is on the corner of Opernring and Operngasse. Herbert von Karajan introduced many stars to the opera house; singers of world renown, among them Maria Callas, Anna Netrebko, Luciano Pavarotti and Placido Domingo, have regularly performed here.

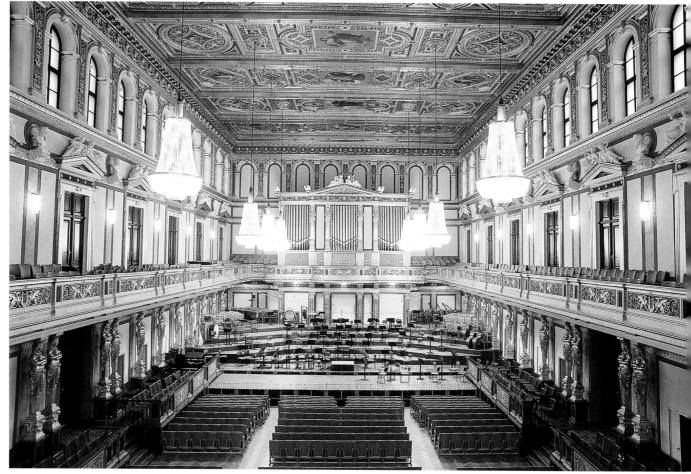

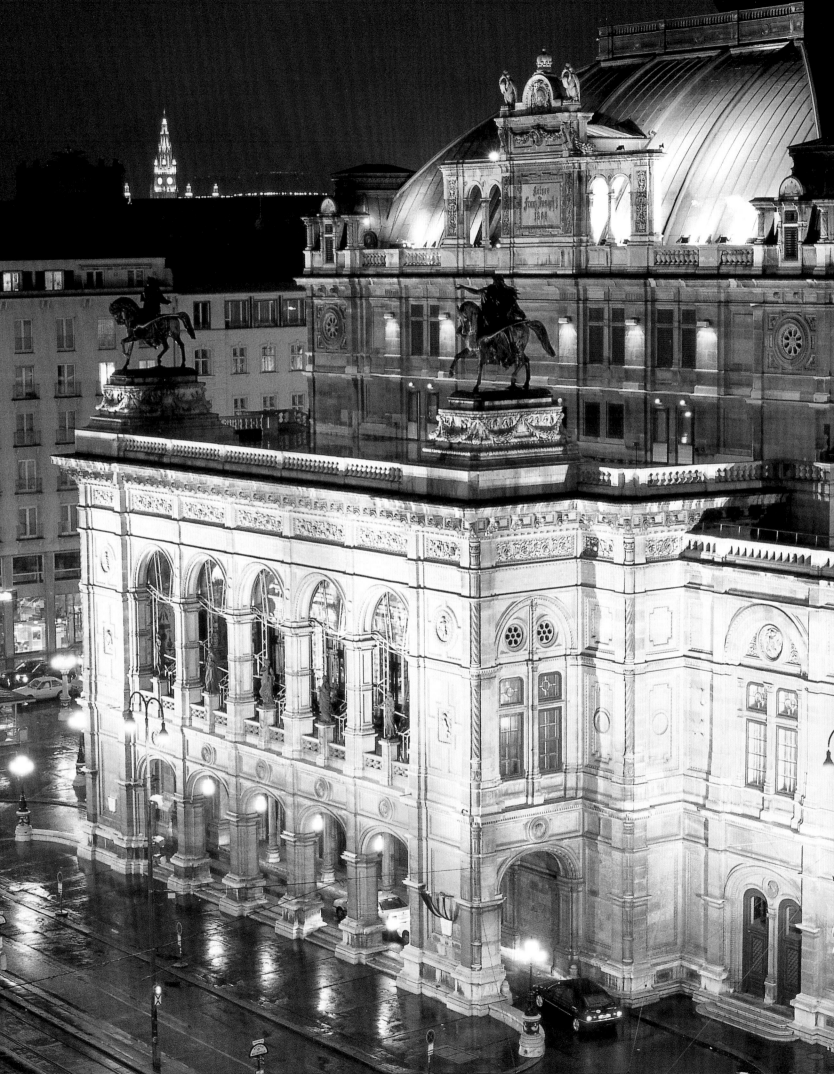

The temple in the middle of the Volksgarten was erected between 1820 and 1823 by Peter von Nobile and based on the Theseion or Temple of Hephaestus in Athens. It originally housed the statue of Theseus by Antonio Canova which is now in the Kunsthistorisches Museum.

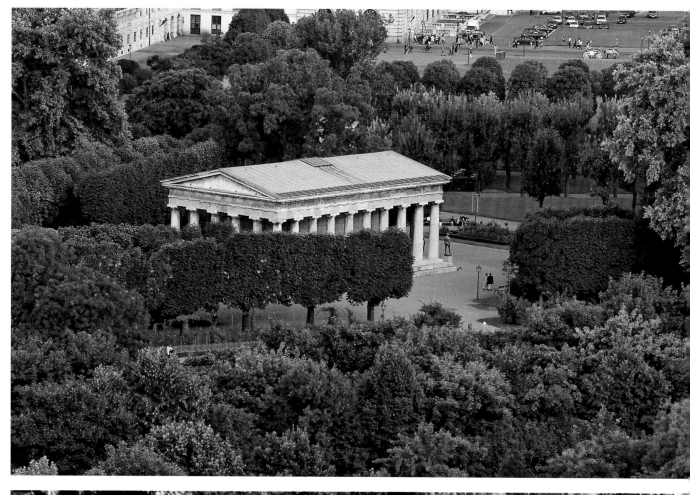

The Volksgarten is a haven of peace and quiet from the hustle and bustle of the city all year round. Here park visitors soak up the weakening rays of golden autumn sunshine, perhaps before setting off to a Kaffeehaus for an afternoon Einspänner or Pharisäer.

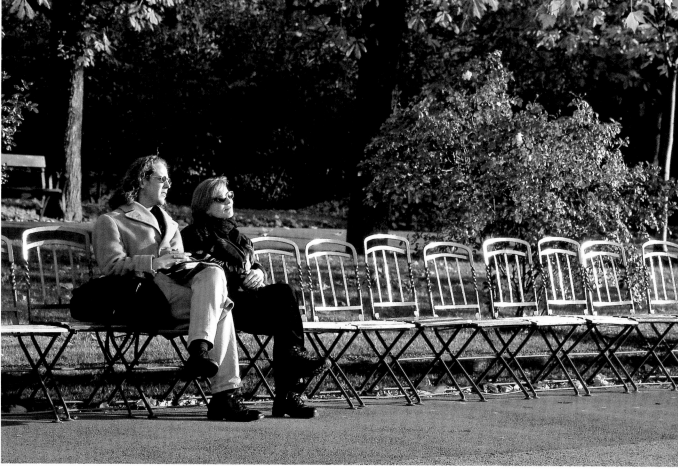

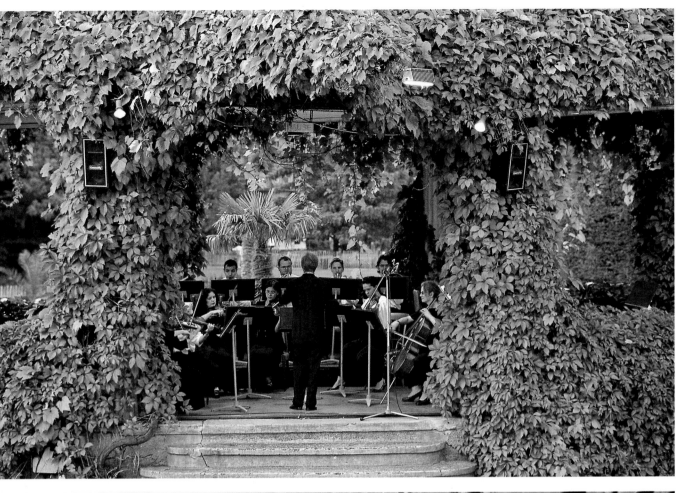

The Kursalon in the Stadtpark was a popular dance and concert venue in the days of the Strauß brothers. The Johann Strauß concerts held here today are also readily frequented – as are the pleasant gardens – by locals and visitors to Vienna alike.

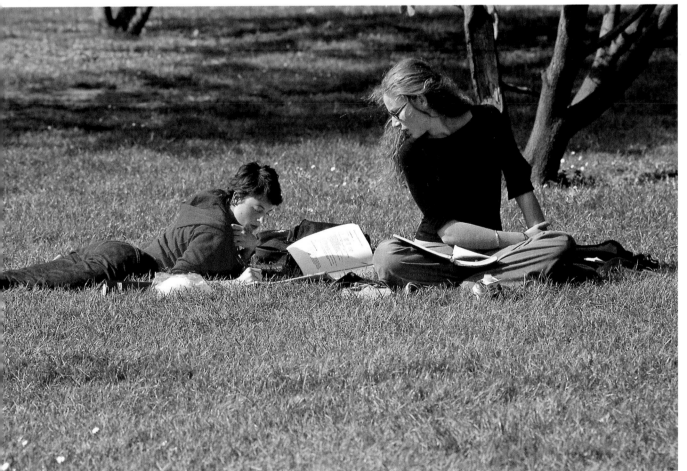

Sigmund Freud would probably smile down benevolently on the young students taking a break in the park named after him. The park is in the 9th district close to the university and was laid out in the 1870s after the votive church was built. In 1997 a ring of trees was planted here to commemorate the 40th birthday of the EU; in 2004 a second ring was added to represent the various new member countries.

Page 58/59:
The Votivkirche or votive church, its filigree spires poking up above the surrounding roofs, was built by Archduke Ferdinand Maximilian, later the emperor of Mexico, who wanted to give thanks that the attempted assassination of his brother Emperor Franz Joseph I had failed.

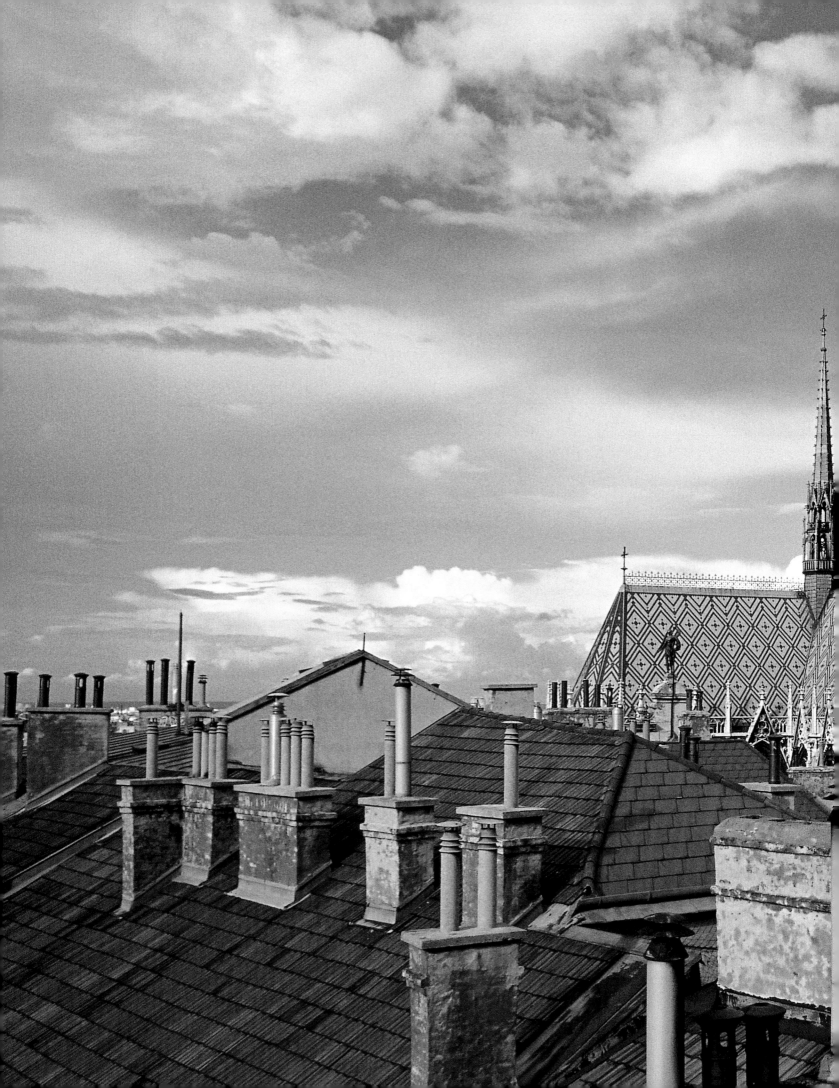

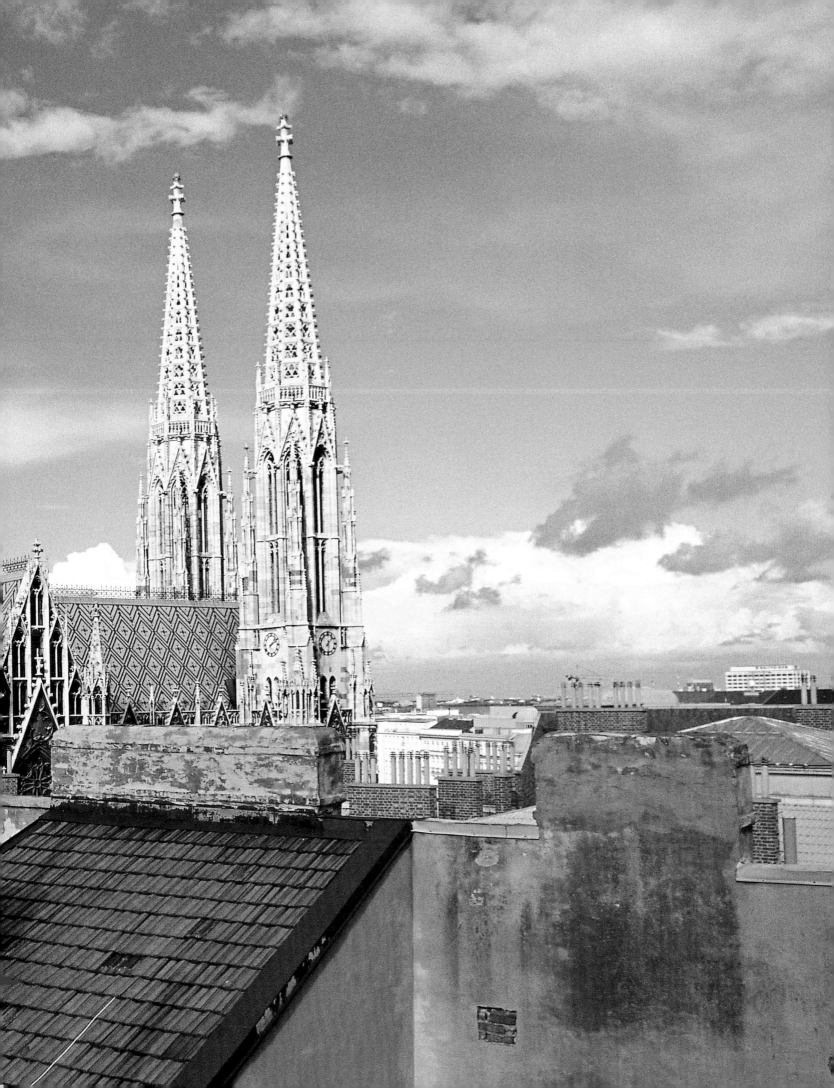

The main hall of the Justizpalast with its insignia of the old Austrian crownlands and the statue of Justice is particularly splendid. The neo-Renaissance building from 1875 to 1881 witnessed a great fire in 1927, commemorated by a memorial plaque. The restored Justizpalast now contains the central library which has been built across one of the inner courtyards as a "reading bridge".

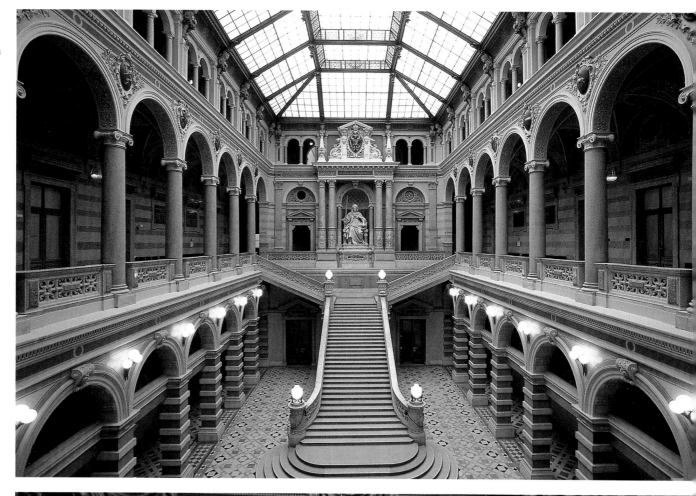

Between 1864 and 1868 a palace was built on Parkring for Archduke Wilhelm by Theophil Hansen; the architect even designed the doorknobs and window latches himself. As Wilhelm was the grand master of the Teutonic Order of Knights he was not allowed to marry and there is accordingly no suite of rooms for a lady of the house. The photo shows the sumptuous hall where the archduke once dined – with or without female guests.

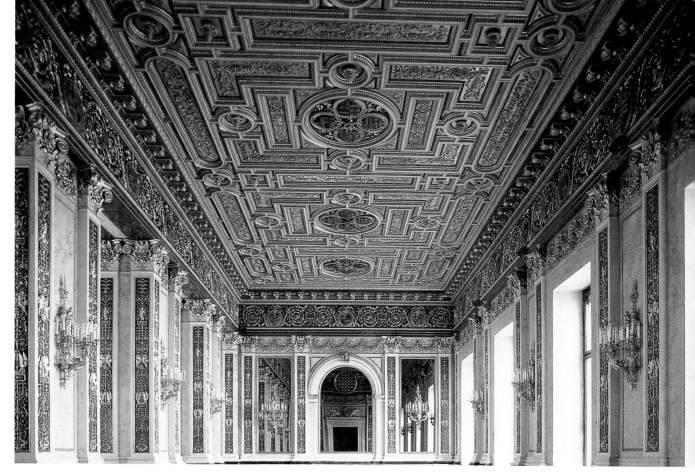

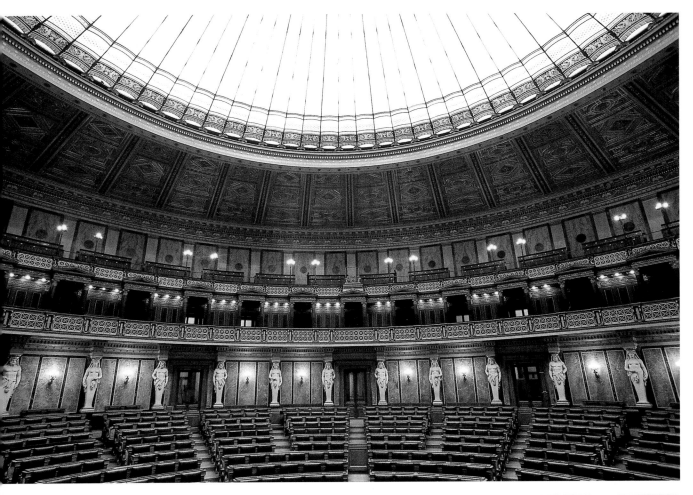

The former hall of representatives at the parliament building on Ringstraße is designed like an antique theatre and decorated with Ionic pillars and marble statues. This is where the Austrian federal convention now convenes.

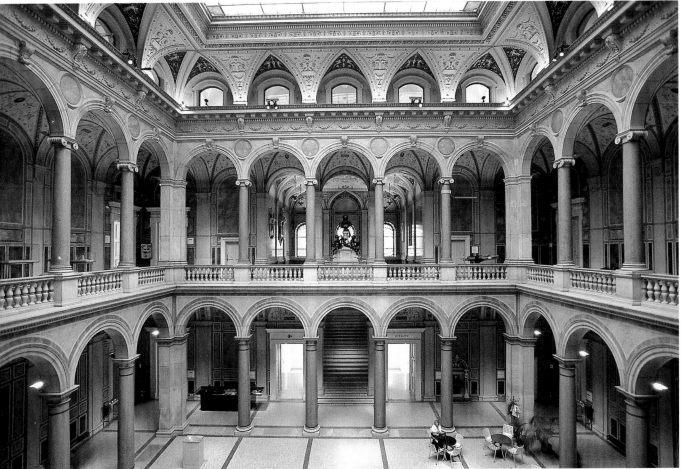

The columned hall at the MAK, Austria's museum of applied art, provides a suitable setting for its diverse collections. Bohemian glass, seats by Thonet and a replica "Frankfurt kitchen" can be admired, as can various works of contemporary art which have found a forum here in the past few years.

61

*"Imperial" at this estab-
lishment refers to both a
building and a gateau.
Stored in a cool place the
sugary version will keep
for weeks; the recipe is
naturally a closely guarded
secret. If you can't make
it to the hotel yourself to
buy one, don't worry; the
cake can also be delivered
by courier.*

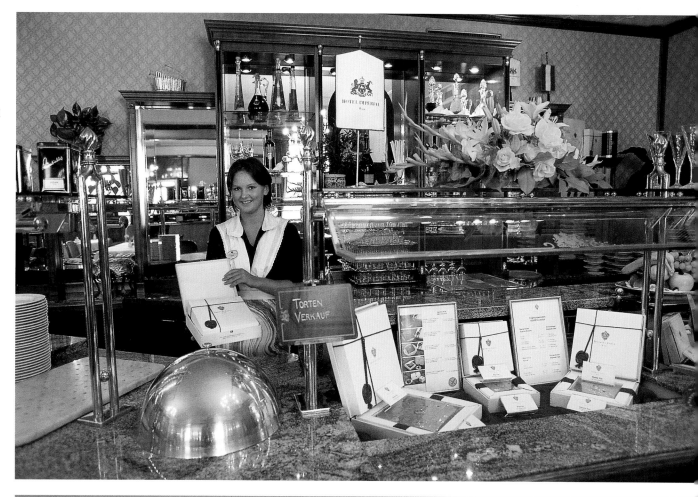

*The entrance hall of the
Grand Hotel on Kärntner
Ring is where the crowned
heads of the world – and
those with enough money
to act accordingly – are
received in style. The
Grand Hotel was the first
of its kind in Europe; on
its opening in 1870 many
of the original rooms had
their own bathroom and
it wasn't long before tele-
phones were introduced.*

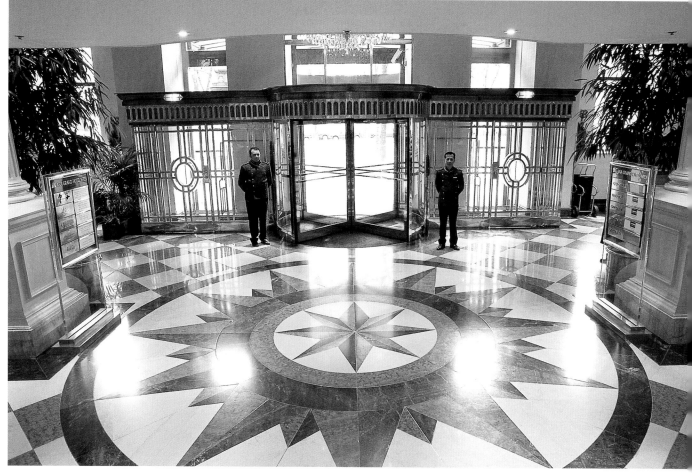

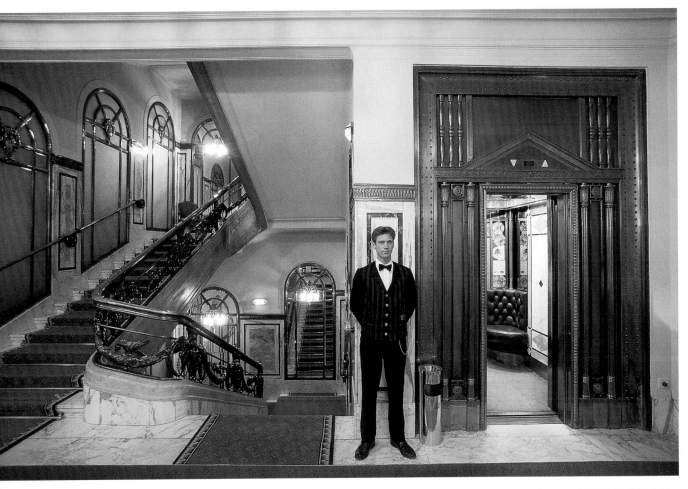

A staircase is much more than a simple flight of stairs in Vienna – as this majestic example at the Hotel Bristol demonstrates. Opposite the Staatsoper on Kärntner Ring this noble auberge is over 100 years old and one of the top establishments in Vienna. It also houses a gourmet restaurant serving creative delicacies within walking distance of the opera.

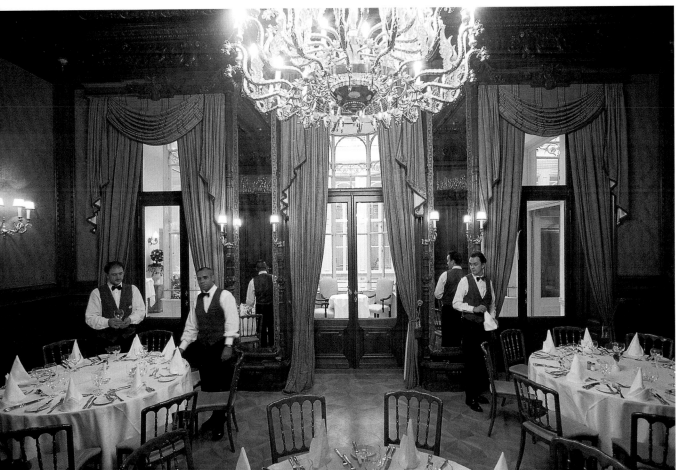

The old smoking room at Palais Leitenberger on Parkring is one of the showpieces of the Radisson SAS Hotel. The palace was joined with the neighbouring Palais Henckel von Donnersmarck to create the present premises.

Page 64/65:
The palm house on the edge of the Burggarten was once used exclusively by the emperor for his entertainment and relaxation. The huge glass structure is now a café and restaurant and where the palace's non-hardy plants are kept over the winter months. One of the big attractions is the butterfly house.

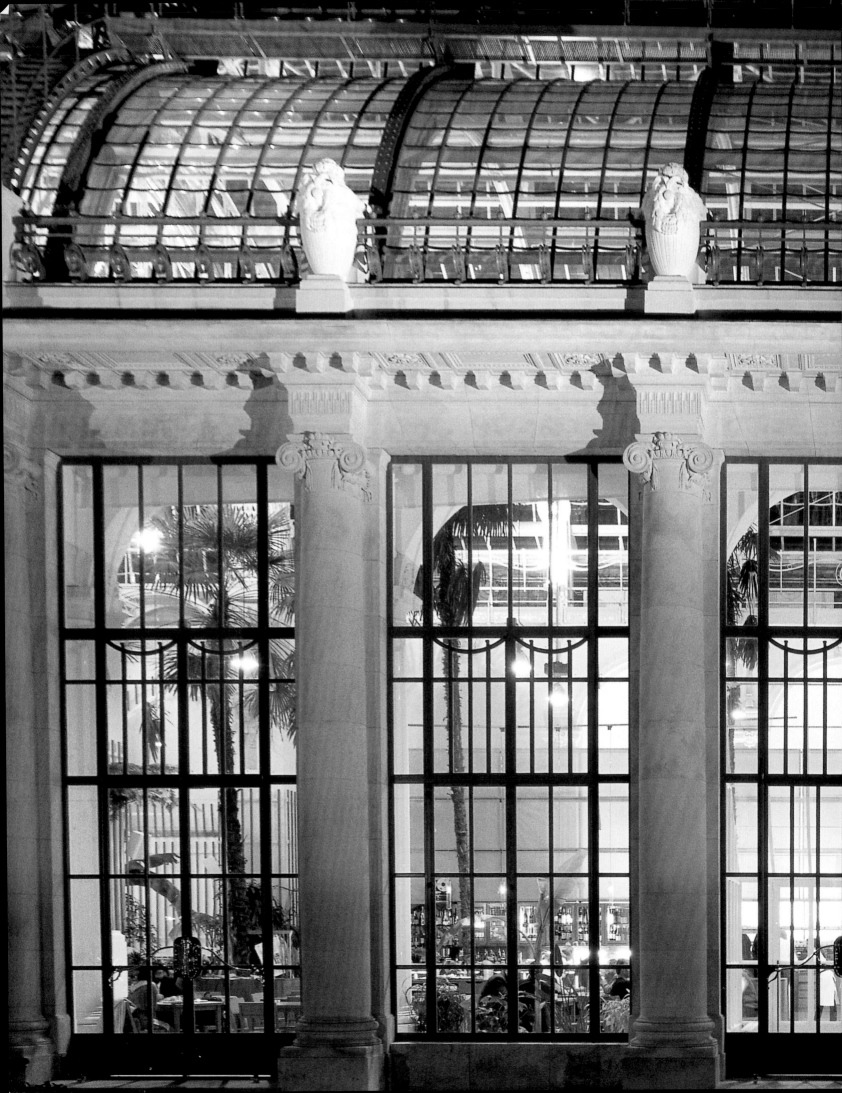

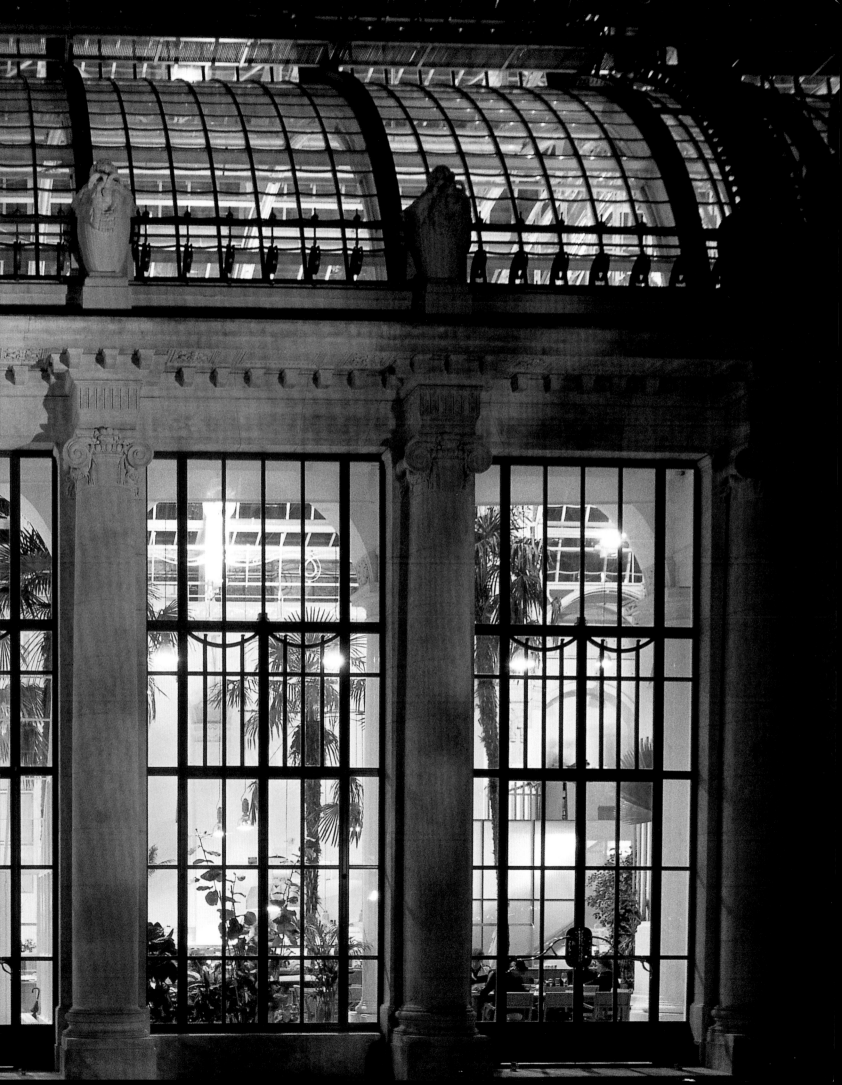

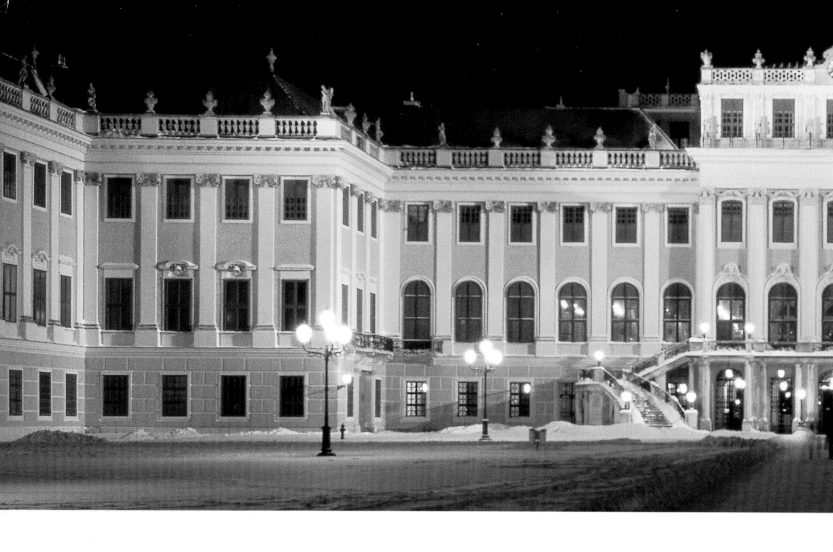

Out in the sticks – from Gürtel to the Vienna Woods

The old suburbs of Landstraße, Mariahilf, Neubau and Josefstadt flank the famous Ringstraße. The *zweiter Bezirk* or second district of Leopoldstadt on the other side of the Danube boasts one of Vienna's most popular landmarks: the enormous Ferris wheel at the Prater fairground. It has since been joined by a host of high-tech rides; if you prefer your visit to the funfair to be a little less stomach-churning, the old-fashioned flair of the Böhmischer Prater on Laaer Berg to the southeast of the city is a better venue. Bus 71 which rides out here is

known as the "widow's express" as the park-cum-fair not far from the Zentralfriedhof or main cemetery – sa to be half as big but twice as amusing as Zürich ...

Life comes before death, however, and who knew better enjoy it than the house of Habsburg. Empress Elisabe may not have felt at home at Schloss Schönbrunn; th 1,441 rooms of the imperial summer residence are, ho ever, an absolute must for any visitor to Vienna. On th Habsburgs' conquering of the Turks Johann Bernha Fischer von Erlach planned a palace which was to su pass even Versailles in size and splendour. The result stunning.

Another product of the city's successful defeat of the Turkish adversaries was the demolishing of the ci defences and the building of Gürtelstraße between th outer city and the suburbs. The city has long becom one huge conglomeration, with the little wine villag of Grinzing and Nussdorf now not far from the outer su urbs. They in turn skirt the Vienna Woods, a popula place of recreation for Vienna's city dwellers.

Much closer to the hearts (and palate) of the Viennese a the many coffee houses, *Beisln*, *Schanigärten* and *Heur gen* pubs and taverns, with a good selection of each in a districts of the city. Everyone has their own favourite one of the most illustrious perhaps is Griechenbei whose guest list has included the likes of Grillparze Nestroy and Mark Twain – and also Beethoven, Brahm and Johann Strauß.

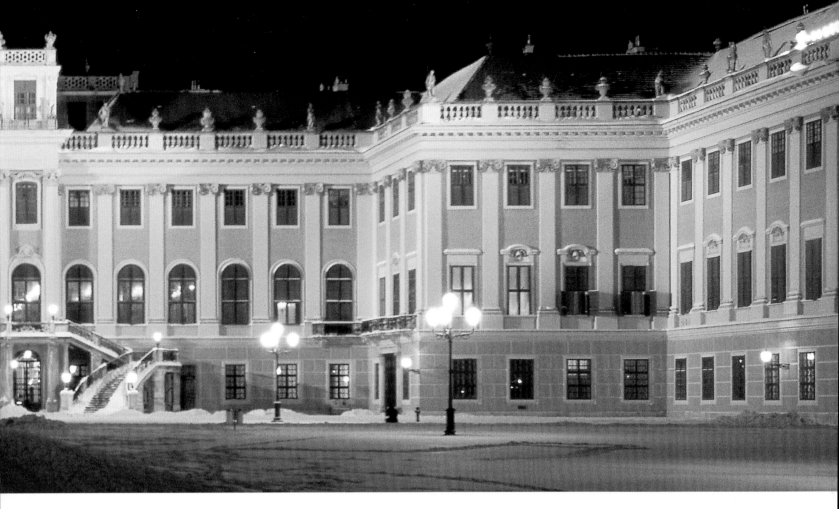

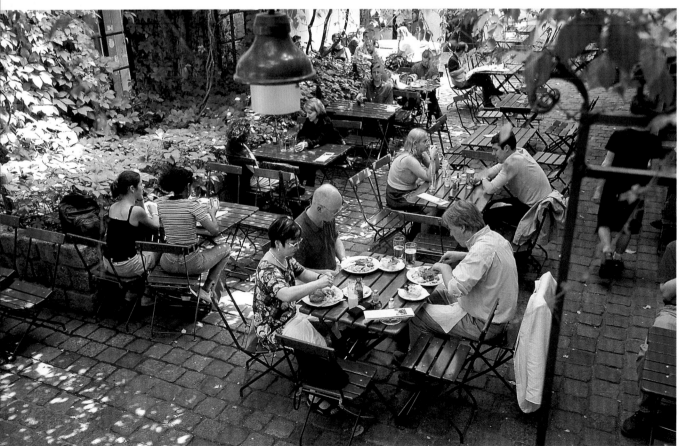

Above:
The most famous of the Habsburgs' residences, Schloss Schönbrunn, glows a warm shade of yellow when lit up at night. The best views of it are from the nearby Gloriette. 39 of the 1,441 opulent rooms are open to the public.

Left:
Amerlingbeisl on Stift-gasse is tucked into the courtyard of the Amerling-haus. Thirty years ago an alternative arts and social centre was set up here on Spittelberg which despite – or perhaps because of – the revamping and subse-quent boom of the area has thrived.

Prince Eugene of Savoy had the palaces of Oberes and Unteres Belvedere built by Johann Lucas von Hildebrandt. Their hallowed halls now accommodate the Austrian Belvedere art gallery which includes the biggest collection of works by Gustav Klimt in the world.

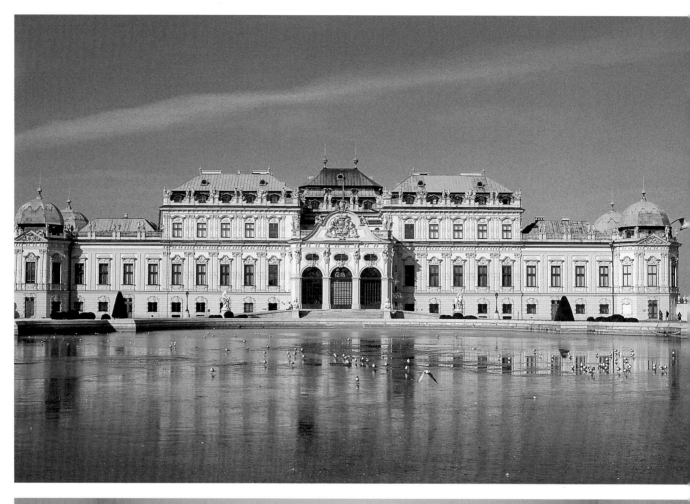

At the Oberes Belvedere one of the rooms is dedicated to Egon Schiele. The palace was originally planned much smaller, forming the architectural conclusion to the palace grounds. At its centre is a hall of marble adorned with a ceiling fresco by Carlo Innocenzo Carlone.

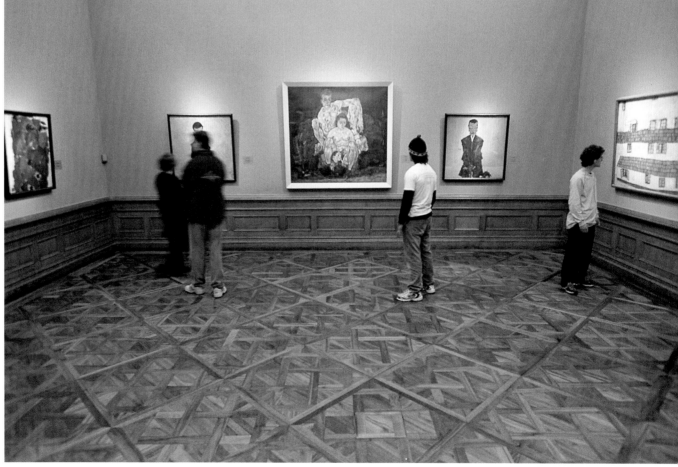

68

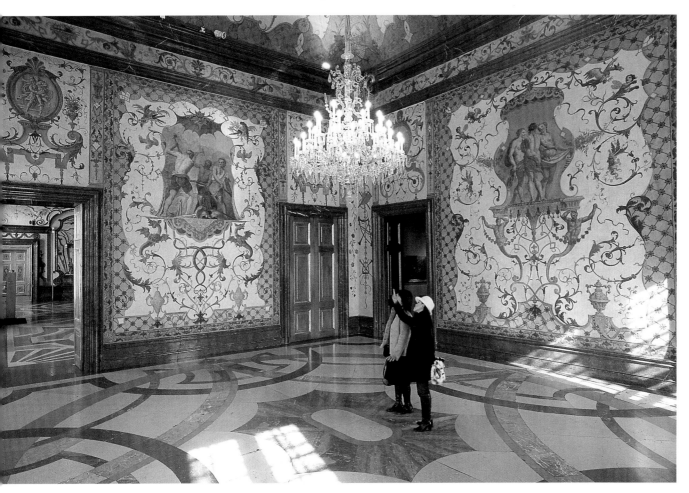

German artist Jonas Drentwett painted the Groteskensaal at Unteres Belvedere with Roman frescoes of mythical creatures. Next door to the palace is the orangery, now a museum of medieval Austrian art. Vanquisher of the Turks Prince Eugene had Versailles in his mind's eye when he commissioned the palace to be built.

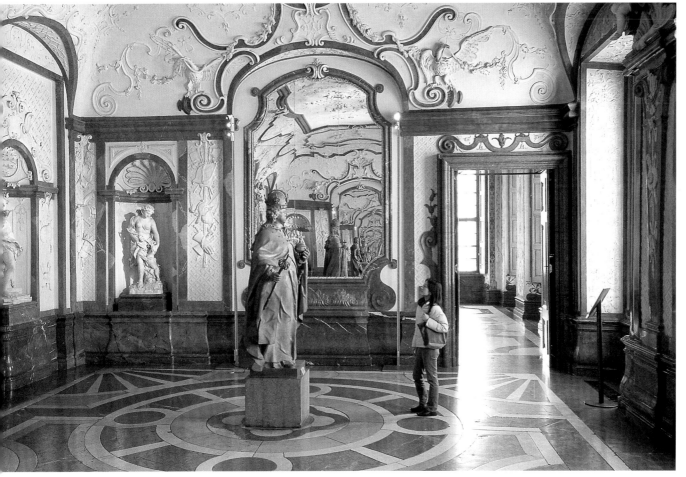

The centrepiece of Unteres Belvedere, the former summer residence of Prince Eugene of Savoy, is also a hall of marble. Today the palace contains a museum of the baroque which includes works by Johann Michael Rottmayr.

For a few years now one of the largest private art collections in the world has again been on view at Palais Liechtenstein. In keeping with the baroque palace the collection concentrates on paintings and statues from this period. The neoclassical library of the Gartenpalais – shown here – was dismantled at a house on Herrengasse and reconstructed here, piece for piece.

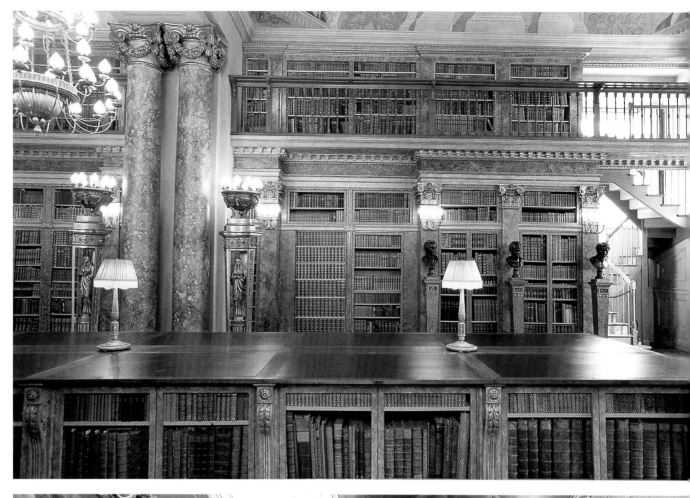

Much of the baroque collection at the Liechtenstein Museum is dedicated to the work of Peter Paul Rubens. Born in Siegen in Germany, the artist wasn't just a painter; he was also a marketing genius, selling his products under the slogan "touched up by the master himself". Rubens' monumental Decius Mus Cycle – shown here – was procured by the count of Liechtenstein in 1693.

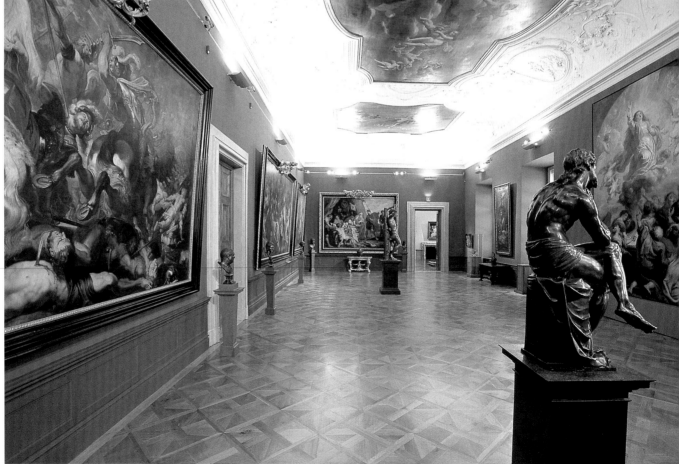

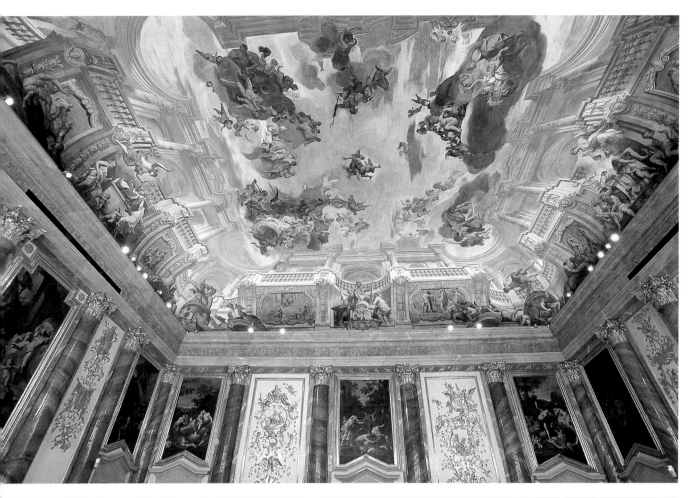

The ceiling fresco in the Herkulessaal of the Liechtenstein Museum was painted by Andrea Pozzo. He was a Jesuit lay brother and leading theoretician on the illusionist art of his day. As he died young, by way of an "ersatz" Johann Michael Rottmayr was commissioned to decorate the ground floor. His work has recently been discovered and excellently restored.

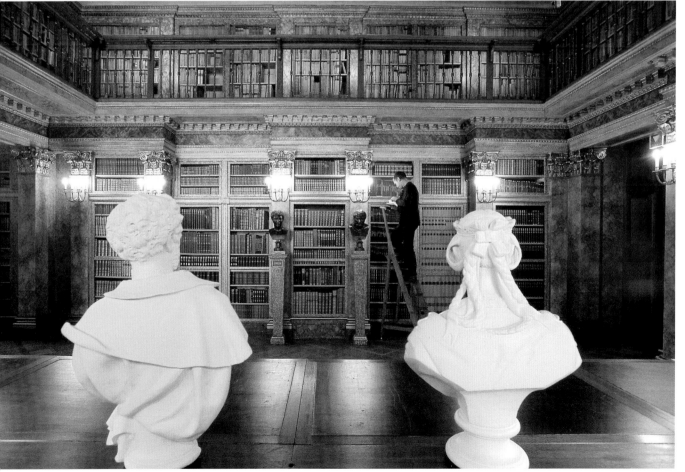

The Majorathaus library, now in the Gartenpalais, has been carefully maintained and its traditions religiously observed from its founder to the present owner, Prince Hans Adam III of Liechtenstein. The latter handed over the running of his principality to his son Alois in 2004. The prince is considered to be the richest monarch in Europe.

Page 72/73:
Although the Danube now circumvents the city rather than flowing through its centre, in the past frequent flooding caused a series of major catastrophes. The arm of the river shown here – the Donaukanal or Danube Canal – was thus regulated and made navigable in 1598; it subsequently proved an important trade route for the city of Vienna.

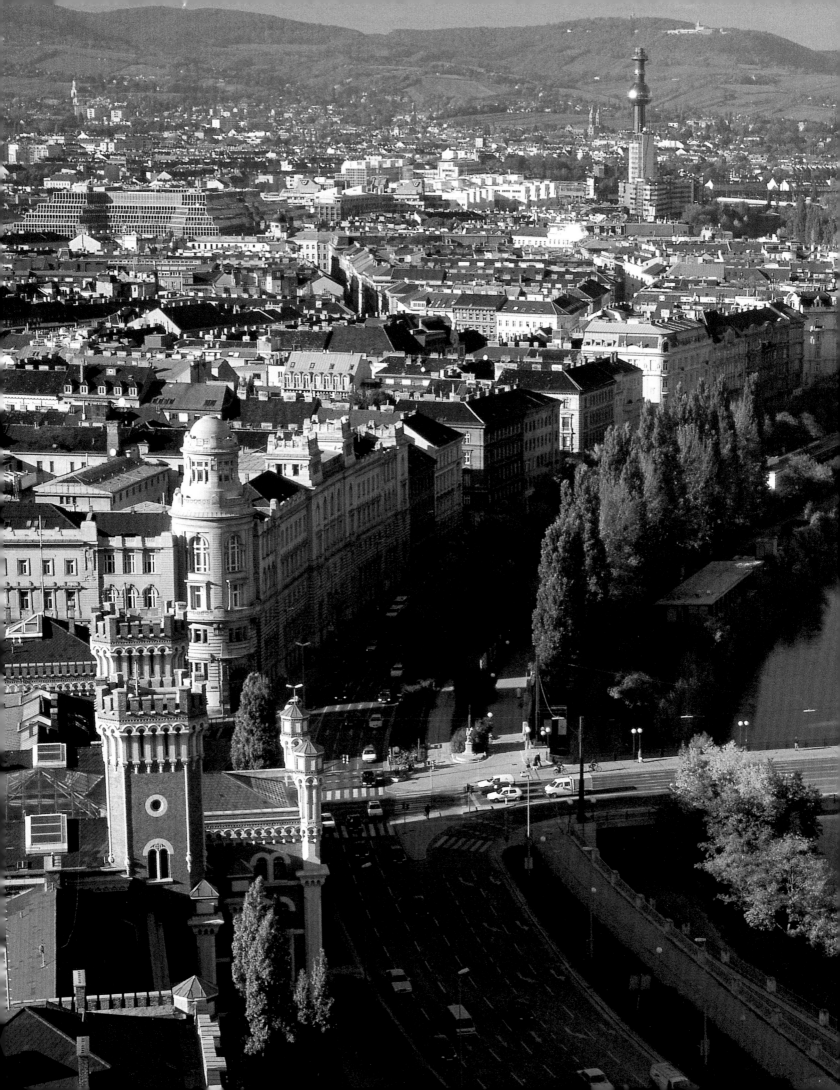

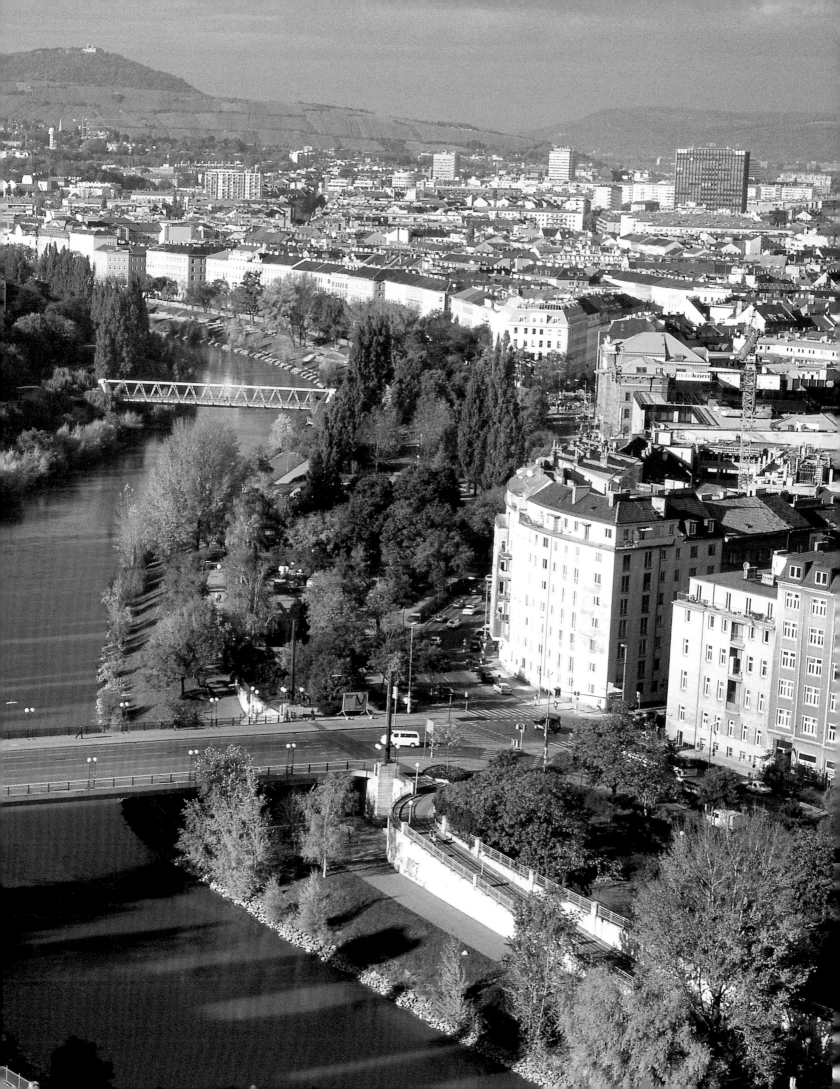

A few years ago the royal stables were converted and extended to create the enormous museum quarter. The complex houses major art museums, such as the MUMOK (museum of modern art), and is also the venue for grand festivals, such as the Wiener Festwochen.

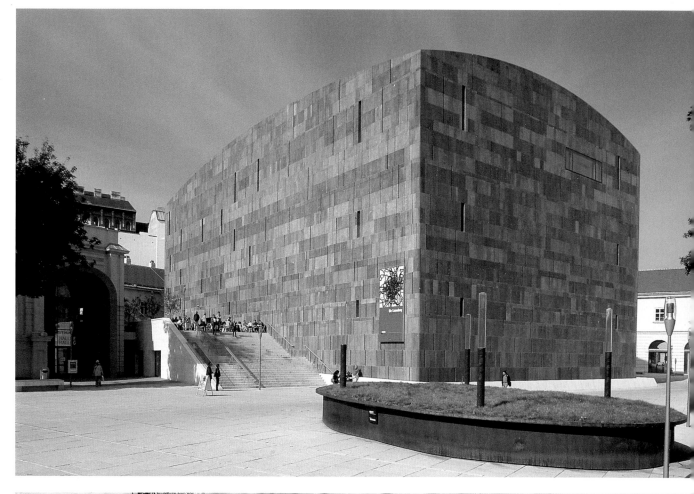

The courtyard of the museum quarter in the heart of the city is a good place to take a break. Both the museums' broad spectrum of art and culture and the sense of calm the area effuses have made the controversial undertaking popular with both locals and visitors alike. The museum quarter is one of the largest cultural venues in the world.

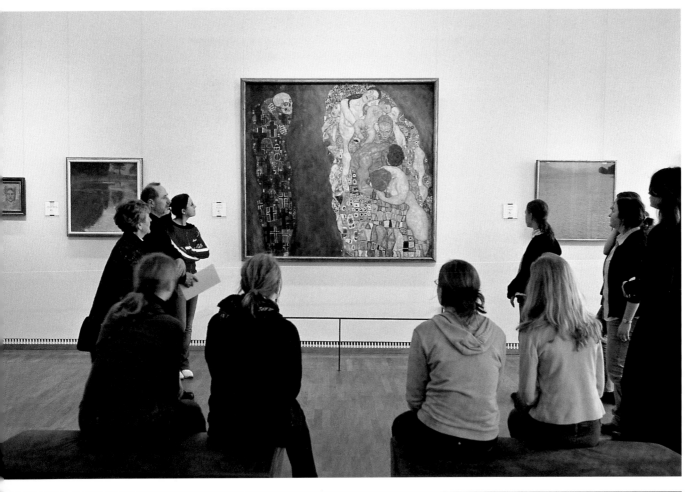

The Leopold Museum has become the most heavily frequented establishment in the quarter. Besides boasting the biggest collection of Egon Schiele works in the world many other major artists, including Oskar Kokoschka and Alfred Kubin, are celebrated here. Perhaps one of the most famous paintings on display is Gustav Klimt's Death and Life, depicted here.

Architects Ortner & Ortner from Vienna were commissioned with the remodelling of the museum quarter. Even the design of the lifts in MUMOK is practical and functional, in contrast to the colourful creations by Pablo Picasso and Andy Warhol on show elsewhere in the building.

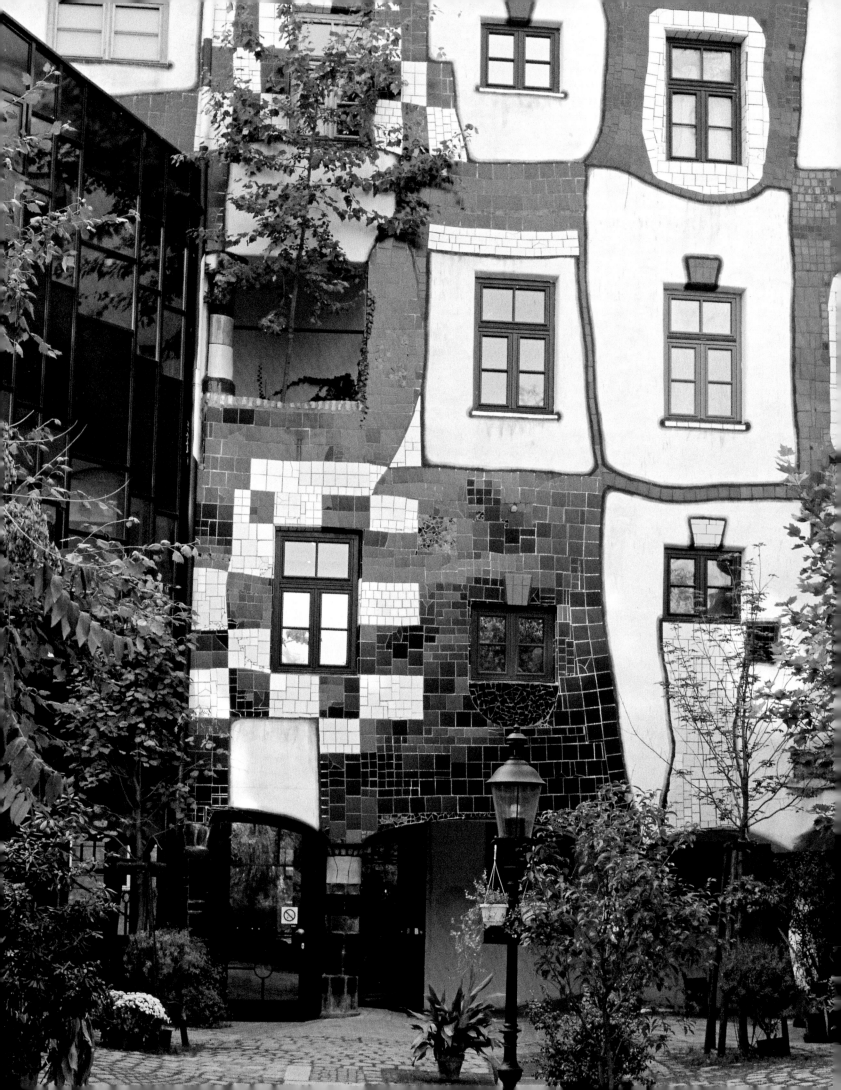

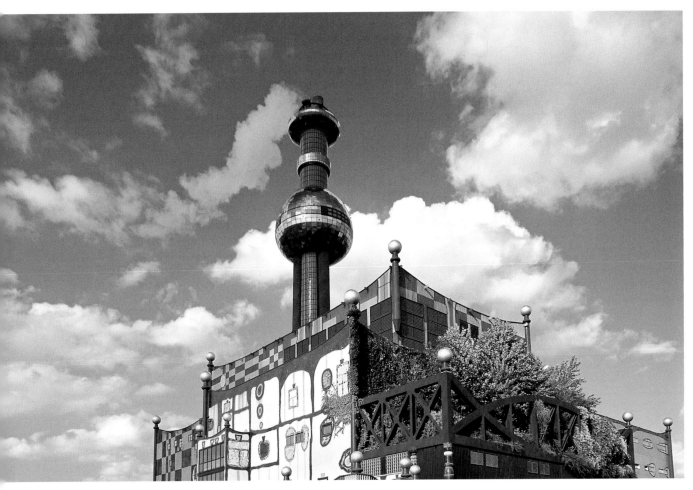

Left page:
Friedensreich Hundertwasser's real name was Friedrich Stowasser, "sto" meaning "a hundred" in many Slavic languages. He also called himself "Regentag" (rainy day) and "Dunkelbunt" (dark colours). The KunstHausWien on Untere Weißgerberstraße he himself designed is a museum dedicated to his life and work.

At first sight the Spittelau incinerating plant looks more like a mosque; it is, however, undoubtedly the work of Friedensreich Hundertwasser. The bright design of this functional building did not meet with the scathing criticism heaped upon the architect's earlier creations. Both wacky and practical, the power plant heats over 60,000 Viennese homes.

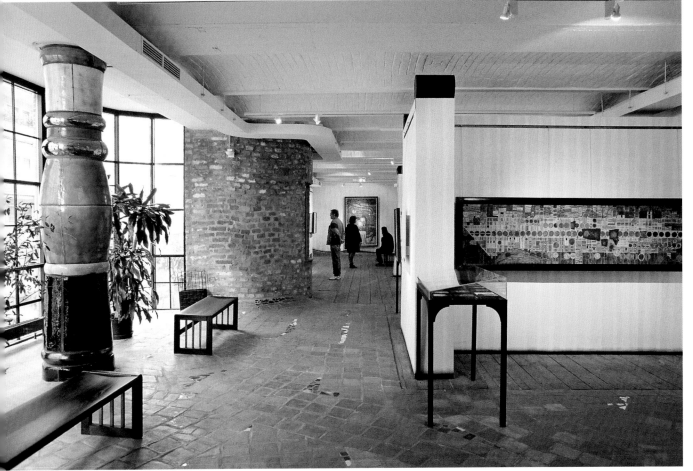

Hundertwasser thought straight lines to be "godless" as they do not occur naturally. Inspired by both Gustav Klimt and Egon Schiele he developed his own individual style. Not only the KunstHausWien is a major attraction; his buildings in Germany, America and Japan and even his public toilette in New Zealand are the subject of many a Hundertwasser pilgrimage.

77

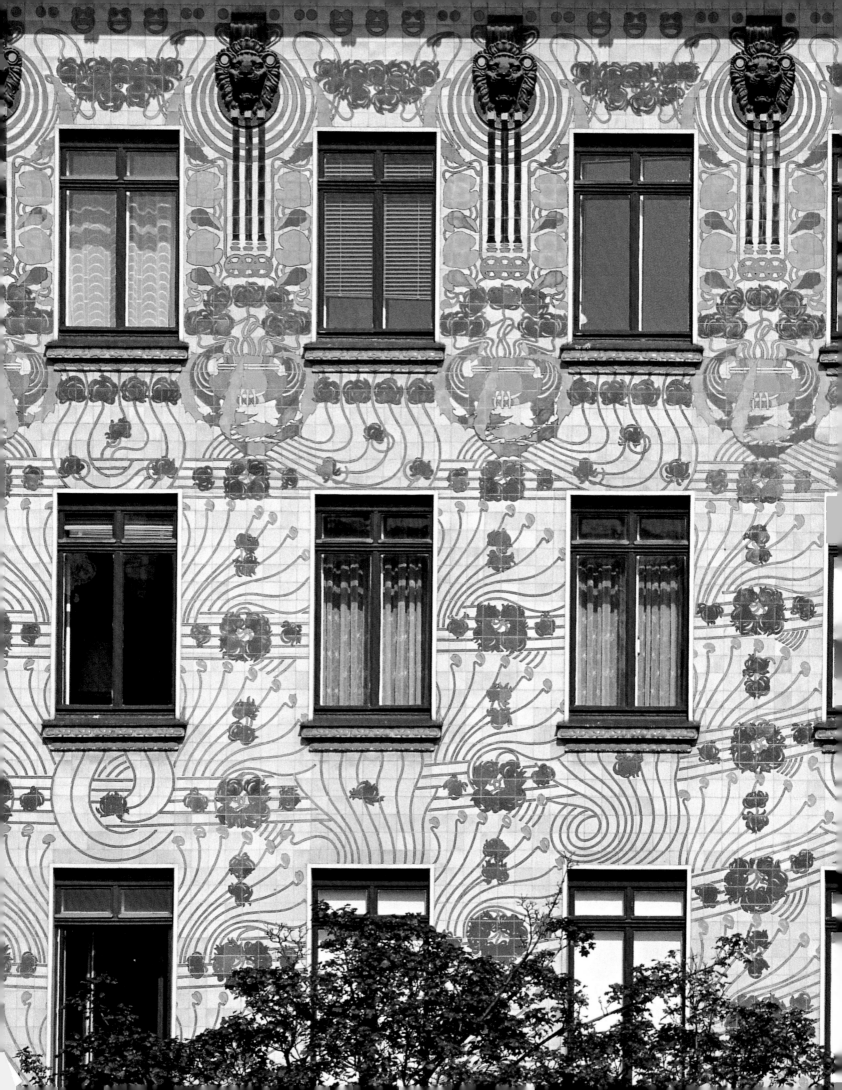

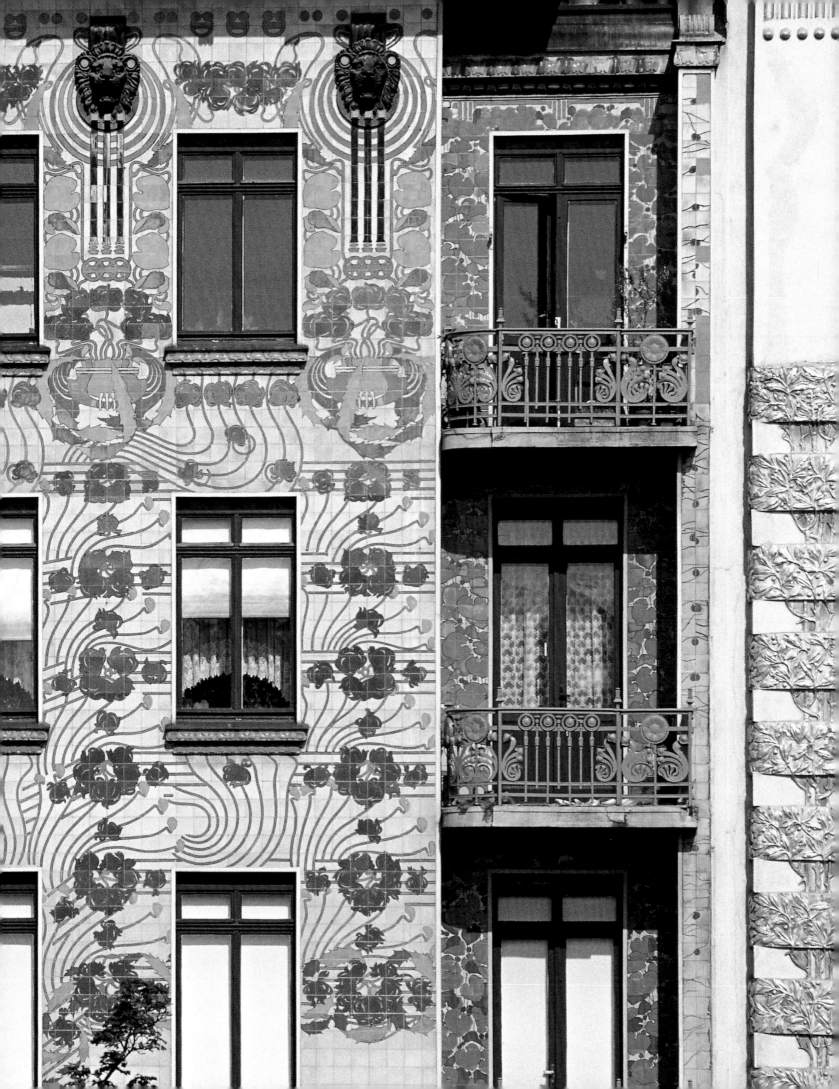

Page 78/79:
After the River Wien had been regulated Otto Wagner wanted to turn the Wienzeile flanking it into a splendid boulevard running from Karlsplatz to Schloss Schönbrunn. The most famous of the three houses he constructed on Linke Wienzeile is the Majolikahaus. The majolica tiles adorning its facade are easy to clean; for the architect and builder hygiene was an important consideration in his modern designs.

The successful synthesis of functionality and aesthetic design at Otto Wagner's savings bank is not only evident in the facade but also in the central hall. The floor is made of glass tiles, beaming natural light down onto bank's "underground" employees on the storey below.

The Heilig-Geist-Kirche (1910–1913) on Ottak-ring, the first reinforced concrete church in Austria, was ridiculed by Austrian heir to the throne Arch-duke Franz Ferdinand as something between "a Russian bath, stable and temple of Venus". Designed by Slovenian architect Jože Plečnik (Josef Plecnik), today it's heralded as one of his most famous works worldwide.

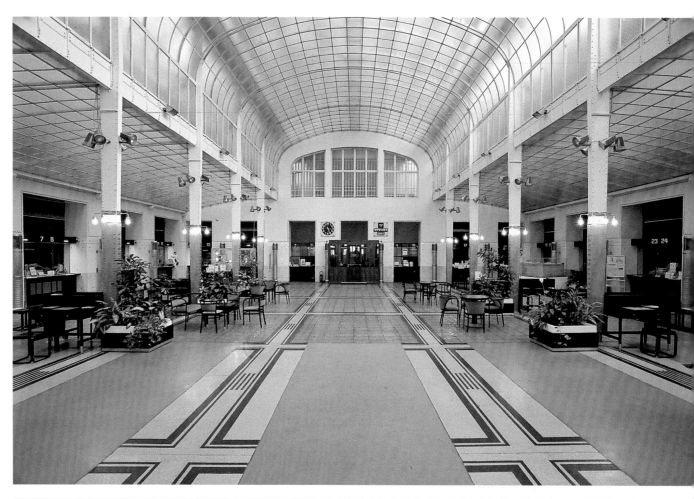

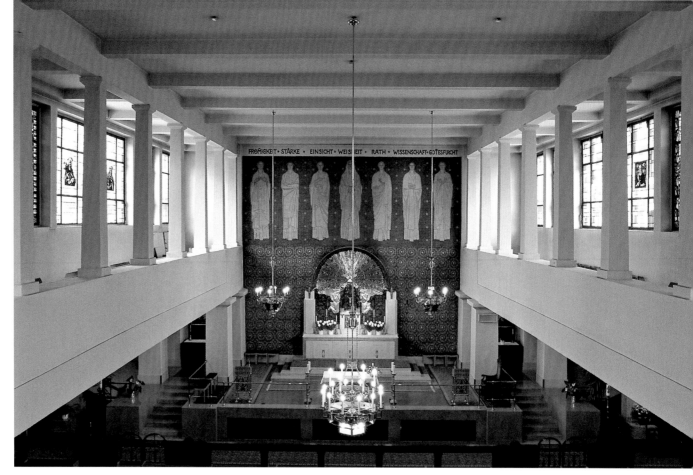

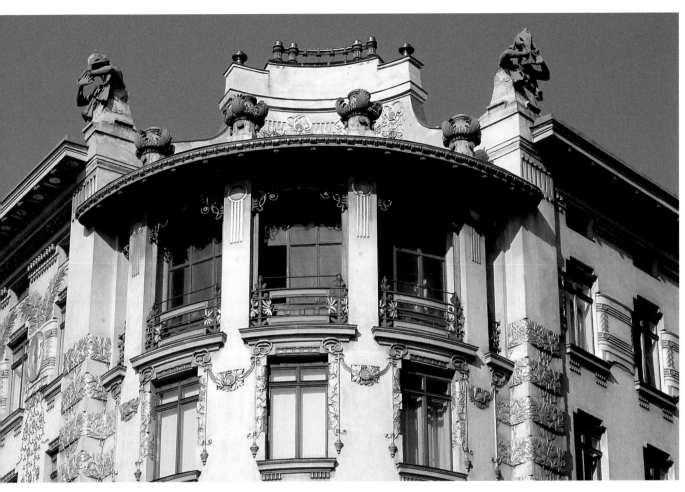

Otto Wagner's building on Linke Wienzeile 38 on the corner of Köstlergasse is famous for its spectacular round apex. Beyond this on Köstlergasse itself is the third and most spartan of Wagner's houses in which the architect lived for a time. It is in this building that he had his legendary glass bathtub installed.

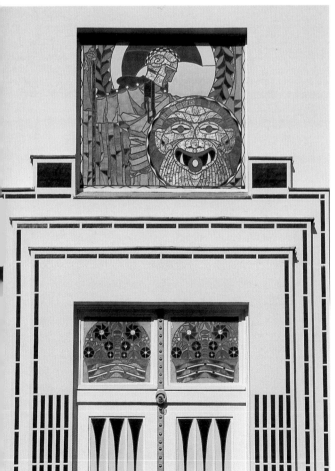

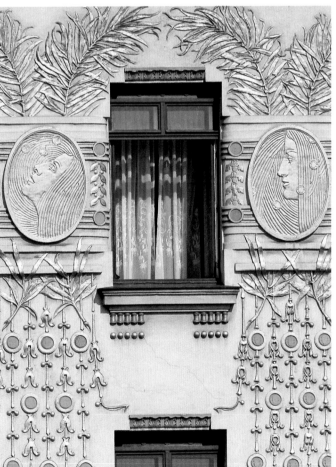

Far left:
The entrance to Villa Wagner II is celebrated by a simple geometric portal enlivened by ornate glasswork. Otto Wagner wasn't just a renowned architect and builder; teaching also played a major role in his life. Several famous architects were to profit from his doctrinal wisdom, among them Josef Hoffmann and Josef Maria Olbrich.

Left:
Koloman Moser made the gold ornaments for the Otto Wagner house on Linke Wienzeile 38. The rooftop is also noted for its impressive female figures sculpted by Othmar Schimkowitz who seem to call out to the people below.

The range of victuals on offer on Naschmarkt is huge. You can buy simple local produce or exotic delicacies from far-off countries, savour organic and vegetarian dishes or grab a quick bite to eat from the sausage stand. Coffee served with the obligatory glass of water is naturally also available …

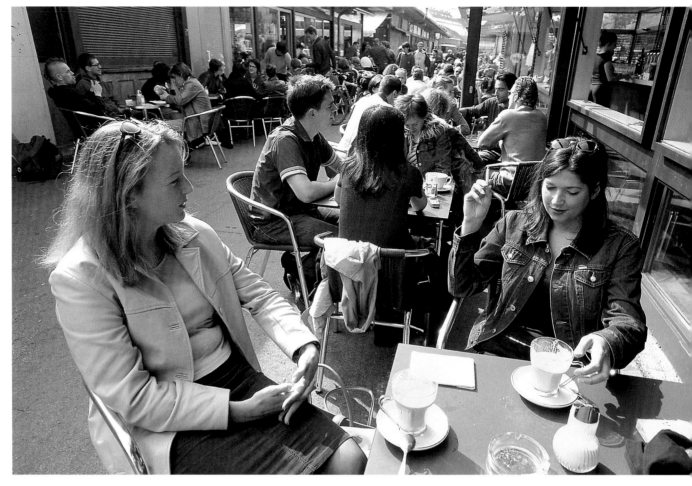

No market would be complete without stalls of delicious-looking, artistically arranged fruit and vegetables – and Naschmarkt is no exception. Hobby cooks can also shop here for fish, meat, bread, cakes, herbs and spices and Italian, Greek and Turkish specialities – in a setting which is far more individual and atmospheric than the neon-lit ordered array at the local supermarket.

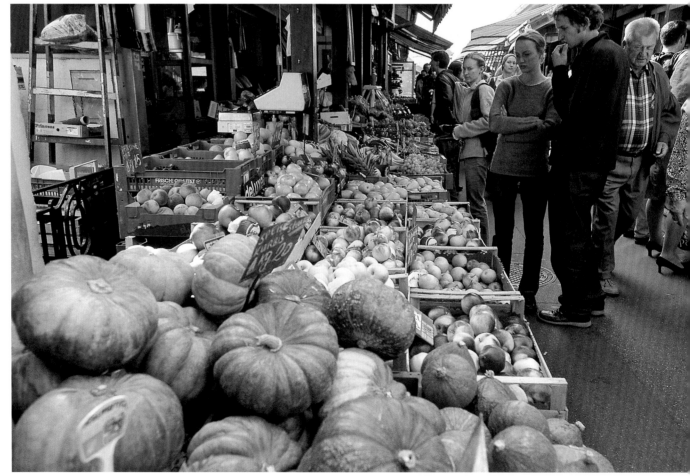

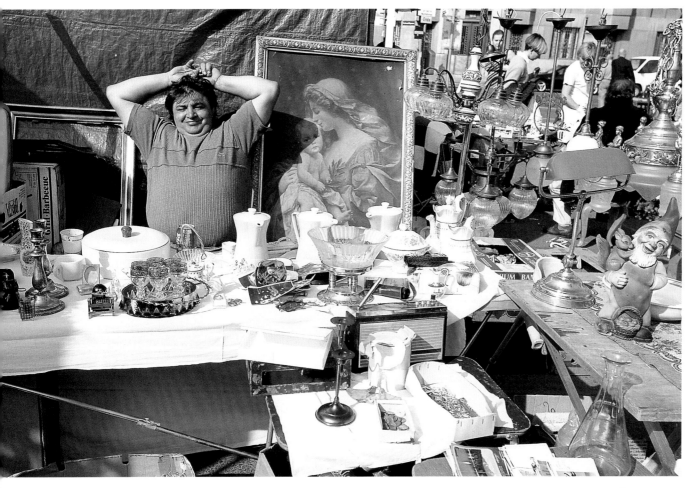

On Saturdays artefacts of various description are on sale at the flea market on Naschmarkt. Here professional antiques dealers tout for custom alongside locals who've just cleared out the attic and kids wanting to make some extra pocket money selling their old toys.

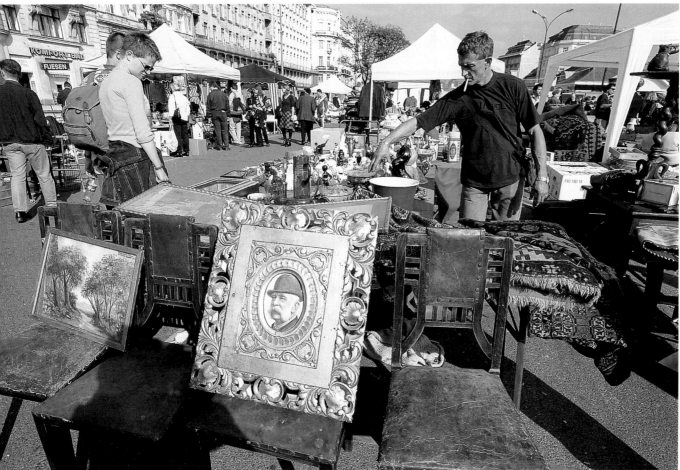

The nostalgic und unique atmosphere of the Naschmarkt flea market has a magnetic attraction, with visitors flocking here in their hundreds in search of a genuine antique or a bit of kitsch for their city apartments.

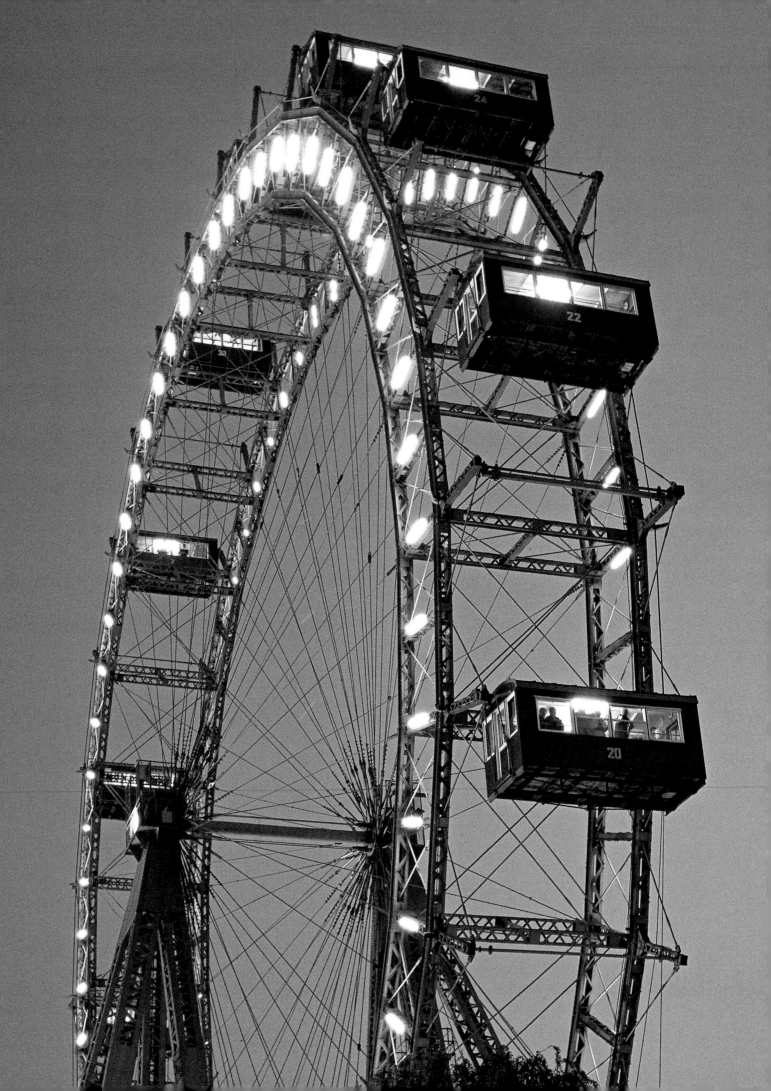

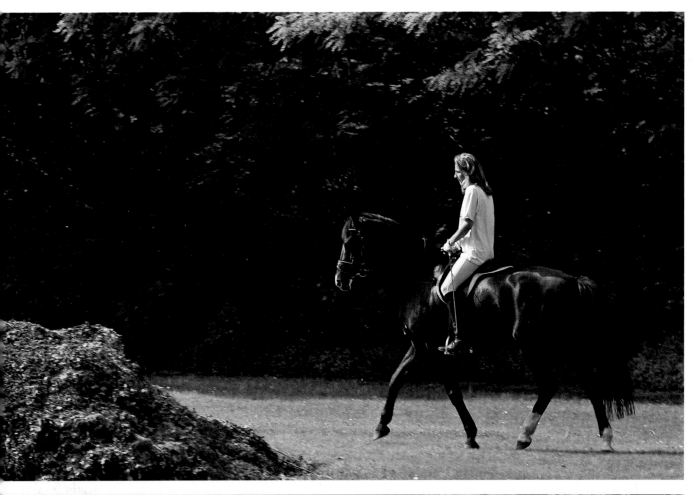

Left page:
One of Vienna's major landmarks is the huge Ferris wheel at the Prater funfair. From the top there are magnificent views of the cathedral and the city right out to the Vienna Woods. The fair has everything from old-fashioned dance halls to high-tech roller coasters – and even a dinosaur park for its younger visitors.

Initially the Prater was only open to nobles who came here for a stroll or a leisurely ride on horseback. Since its opening to the public the expansive park on the banks of the Danube has become an eldorado for ambitious riders of all denominations, complete with equestrian clubs and bridleways.

The enormous Prater tucked in between the River Danube and the Danube Canal has many an idyllic spot where you can escape the noise and fumes of the metropolis. Here on Heustadelwasser you even can laze away a few hours on the serene waters of the park.

This house on what is now Haydngasse is where Joseph Haydn (1732–1809) wrote much of his late oeuvre. One of his greatest admirers was Johannes Brahms (1833–1897), to whom a room at the museum is also dedicated. The clavichord acquired by Brahms is said to have belonged to his mentor Haydn.

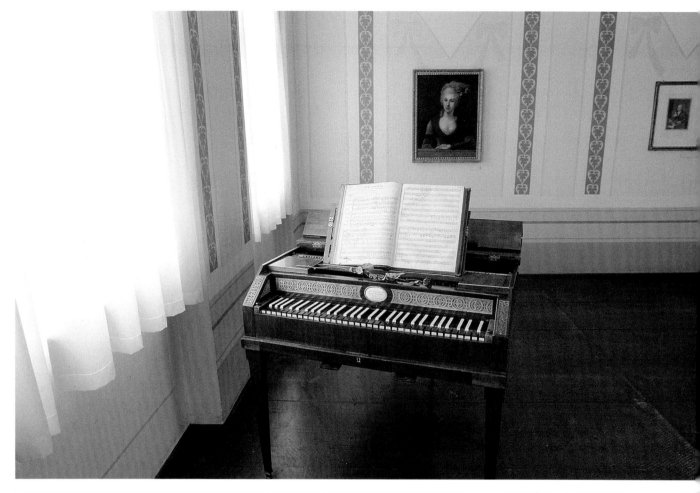

The life and work of contemporary composer Arnold Schönberg (1874–1951), who designed both a machine which wrote music and one for drawing staves, is commemorated in his native city of Vienna. A few years ago the Arnold Schönberg Center was opened at the Palais Fanto. Among the items on display is his study.

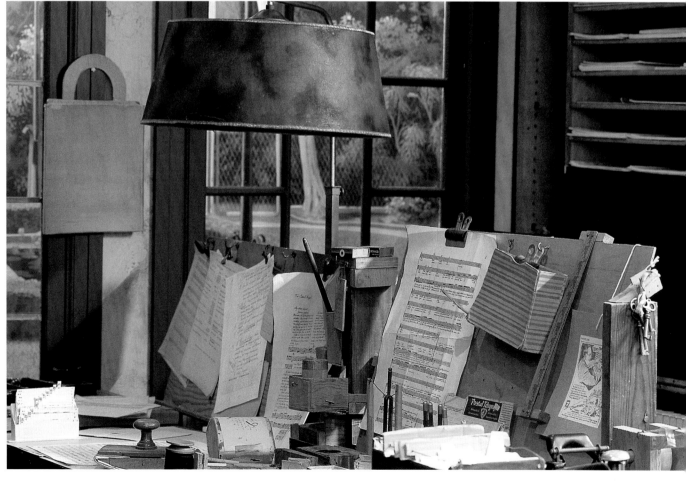

Psychoanalyst Sigmund Freud lived and worked in this house for 47 years before moving himself and much of his furniture – including the infamous couch – to London. The museum includes a mock-up of his waiting room.

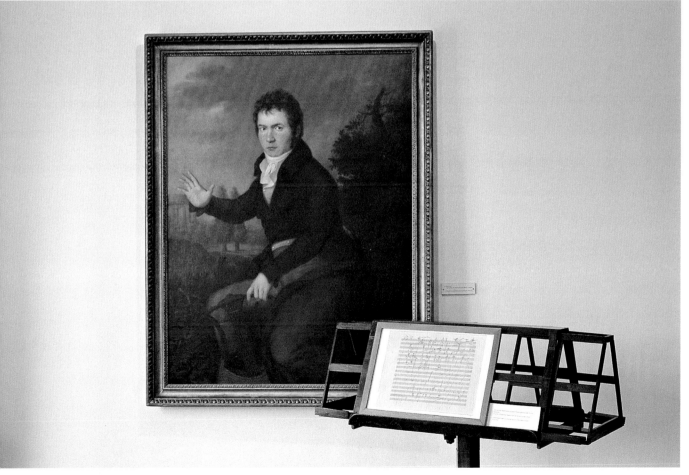

The Pasqualati-Haus, in which Ludwig van Beethoven was permitted to spend a few years thanks to the generosity of his patron, is now a museum devoted to the great composer. This is where he wrote Für Elise, among other pieces. During the 19th century this portrait of Beethoven by Joseph Mähler became famous, widely circulated as a lithograph.

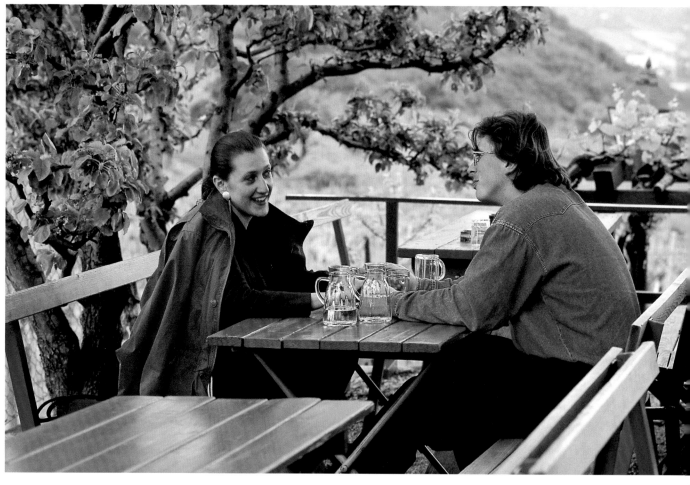

A visit to the Sirbu Heuriger on Kahlenbergstraße in the 19th district is akin to a pub walk; the nearest bus stop and train station are some distance away! It's worth it, however – not just for the food and drink but also for the fantastic vistas of Vienna, sprawled beneath you in all its splendour.

Top right:
Sievering was first mentioned in 1114 as Sufringen. By the beginning of the 19th century much of it was covered with vines, the produce of which can be tasted at the charming taverns on Sieveringerstraße.

Bottom right:
The word "Sturm!" doesn't necessarily signify warning of an impending gale in Vienna. As here on Naschmarkt it can mean that this is where the new autumn wine can be bought.

Far right:
Before going to a Heuriger – like this one on Sieveringerstraße – the more professional visitors consult their Heuriger calendar to see who's open when. Then it's off to the tavern of their choice for some house wine and traditional Viennese fare.

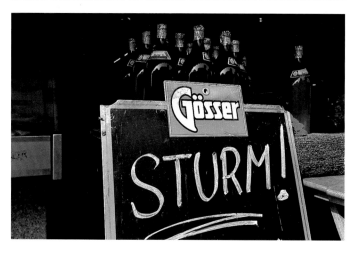

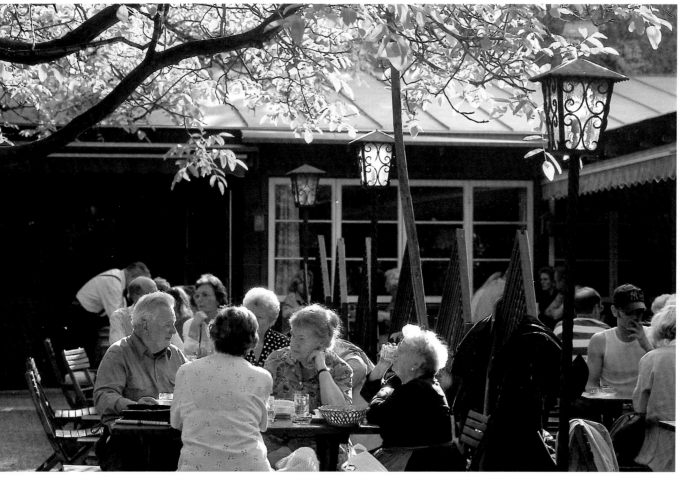

Vienna's very own brand of folk music is said to have originated here at the Schübel-Auer Heuriger on Kahlenbergerstraße 22. This is where brothers Johann and Josef Schrammel formed a quartet who wrote and performed songs such as Wien bleibt Wien (Vienna shall always be Vienna) and the like – still extremely popular today.

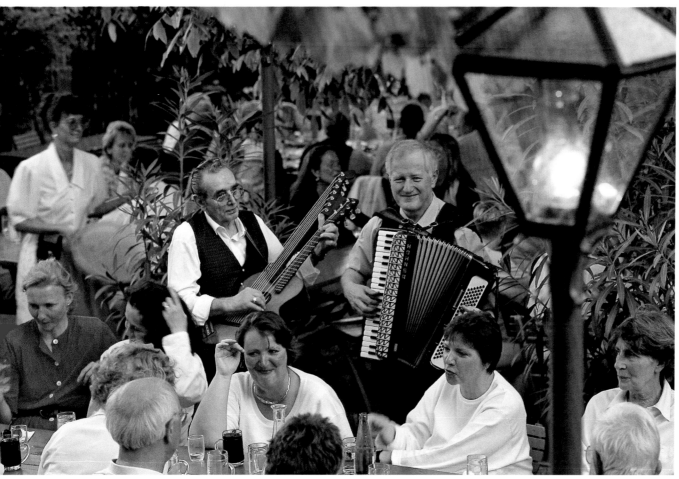

Heuriger Mayer in the 19th district is still at number 2 Pfarrplatz where Beethoven spent the summer of 1817 while looking for a cure for his loss of hearing in Heiligenstadt. It was here that he worked on his greatest work, his 9th symphony.

REGISTER

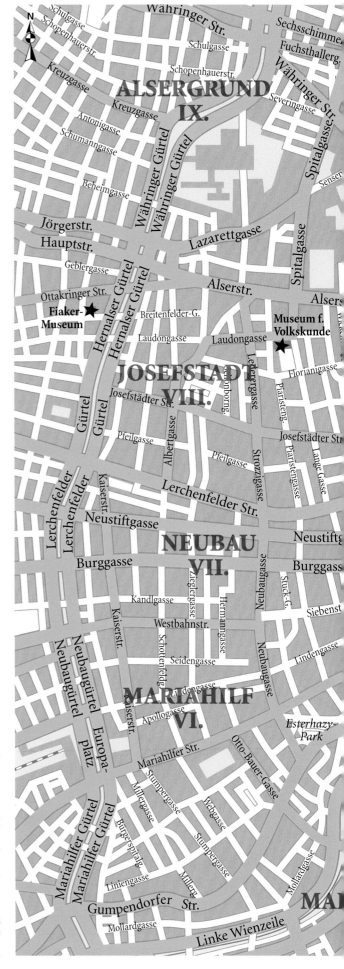

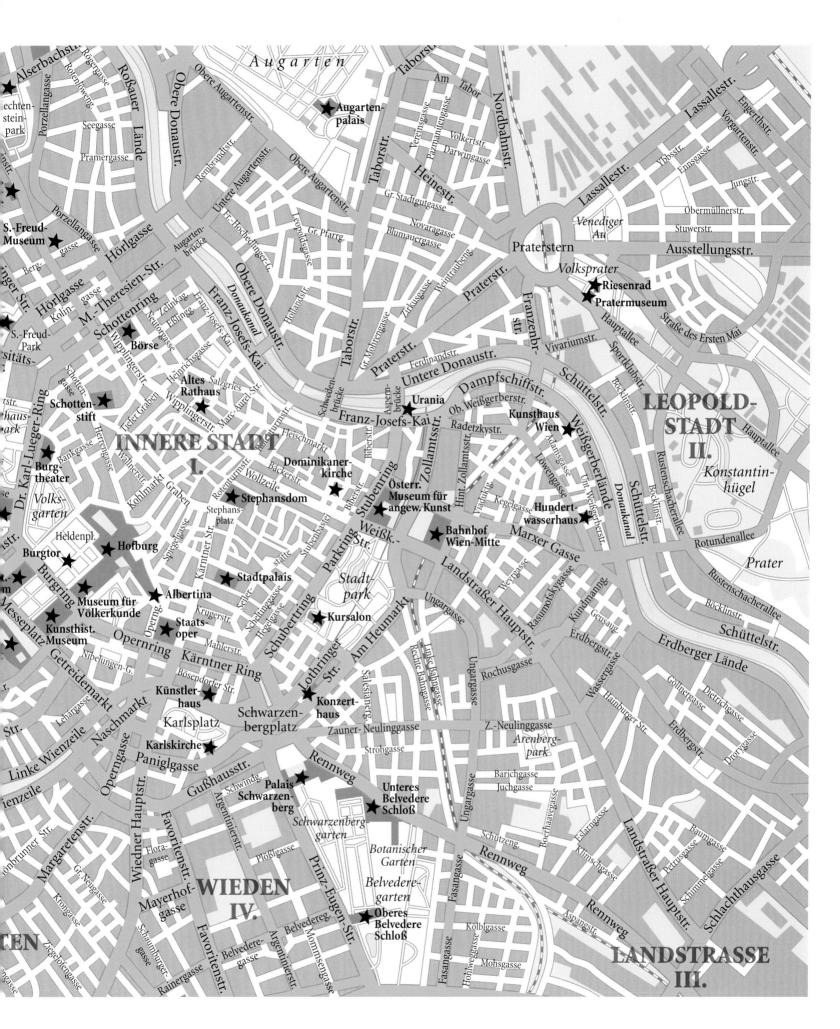

Augarten

Alserbachstr.

Rogergasse
Rotenlöweng.

Porzellangasse

Roßauer Lände

Obere Augartenstr.

Obere Augartenstr.

Am Tabor

Taborstr.

Nordbahnstr.

Lassallestr.

Engerthstr.

Vorgartenstr.

echten-
stein-
park

Seegasse

Obere Donaustr.

★ **Augarten-
palais**

Vereinsgasse

Pazmanitengasse

Volkertstr.

Darwingasse

Lassallestr.

Ybbsstr.

Ennsgasse

Jungstr.

Pramergasse

Obere Donaustr.

Heinestr.

Gr. Stadtgutgasse

Obermüllnerstr.

★

Porzellangasse

Rembrandtstr.

Untere Augartenstr.

Fr.-Hochedlinger-G.

Augarten-
brücke

Taborstr.

Novaragasse

Blumauergasse

Venediger
Au

Stuwerstr.

★ **S.-Freud-
Museum**

Hörlgasse

Kolin-
gasse

Gr. Pfarrg.

Leopoldsgasse

Praterstern

Ausstellungsstr.

Hörlgasse

M.-Theresien-Str.

Schottenring

Franz-Josefs-Kai

Obere Donaustr.

Donaukanal

Gr. Mohrengasse

Praterstr.

Franzensbr.-
Str.

Volksprater

★ **Riesenrad**
★ **Pratermuseum**

Straße des Ersten Mai

★

S.-Freud-
Park

Zelinkag.

Franz-Josefs-Kai

Eßlingg.

Neutorgasse

★ **Börse**

Heinrichsgasse

Zirkusgasse

Weintraubeng.

Franzenbr.-
Str.

Hauptallee

★

Schotten-
gasse

Wipplingerstr.

Salzgries

★ **Altes
Rathaus**

Marc-Aurel-Str.

Ferdinandstr.

Untere Donaustr.

Dampfschiffstr.

Vivariumstr.

Sportklubstr.

LEOPOLD-
STADT
II.

Schottenstr.

Tiefer Graben

Wipplingerstr.

Rotenturmstr.

Schwedenbrücke

Aspernbrücke

Franz-Josefs-Kai

★ **Urania**

Ob. Weißgerberstr.

Radetzkystr.

★ **Kunsthaus
Wien**

Schüttelstr.

Böcklinstr.

Hauptallee

*Konstantin-
hügel*

★ **Schotten-
stift**

INNERE STADT
I.

Fleischmarkt

Wollzeile

Bäckerstr.

★ **Dominikaner-
kirche**

Stubenring

Biberstr.

Zollamtsstr.

Hint. Zollamtstr.

Adamsgasse

Weißgerberlände

Löwengasse

Viadukte

Kegelgasse

Unt. Weißgerberstr.

Rustenschacherallee

Schüttelstr.

Dr. Karl-Lueger-Ring

Bankgasse

Herrengasse

★ **Burg-
theater**

Kohlmarkt

Graben

★ **Stephansdom**

Stephans-
platz

Rotenturmstr.

Stubenbastei

Weißk.-
Str.

Parking

Österr.
Museum für
angew. Kunst ★

★ **Hundert-
wasserhaus**

haus-
ark

*Volks-
garten*

Heldenpl.

★ **Hofburg**

Kärntner Str.

Spiegelgasse

Himmelpfortg.

Stubenbastei

★ **Bahnhof
Wien-Mitte**

Marxer Gasse

Weyrgasse

Rasumofskygasse

Kundmanngasse

Geusaug.

Prater

★ **Burgtor**

Burgring

Burggasse

★ **Museum für
Völkerkunde**

★ **Albertina**

Operng.

Krugerstr.

Seilerstätte

Schellinggasse

*Stadt-
park*

Landstraßer Hauptstr.

Linke Bahngasse

Ungargasse

Rochusgasse

Erdbergstr.

Böcklinstr.

Rustenschacherallee

Schüttelstr.

Erdberger Lände

Messeplatz

★ **Kunsthist.
Museum**

Getreidemarkt

Opernring

Kärntner Ring

★ **Staats-
oper**

Mahlerstr.

Schubertring

Lothringer
Str.

Am Heumarkt

★ **Kursalon**

Salesianerg.

Rechte Bahngasse

Ungargasse

Wassergasse

Hamburger Str.

Erdbergstr.

Göllnergasse

Dietrichgasse

Nibelungen-G.

Kärntner Ring

Schwarzen-
bergplatz

★ **Konzert-
haus**

Zauner-

Neulinggasse

Z.-Neulinggasse

*Arenberg-
park*

Drorygasse

★ **Künstler-
haus**

Karlsplatz

Strohgasse

Barichgasse

Juchgasse

Linke Wienzeile

Naschmarkt

Opernring

Paniglgasse

Gußhausstr.

Rennweg

Schwindg.

Argentinierstr.

★ **Palais
Schwarzen-
berg**

★ **Unteres
Belvedere
Schloß**

Ungargasse

Fasangasse

Boerhaavegasse

Eslarngasse

Klimschgasse

Baumgasse

Petrusgasse

Schimmelgasse

Schlachthausgasse

Landstraßer Hauptstr.

★ **Karlskirche**

ienzeile

Margaretenstr.

Wiedner Hauptstr.

Favoritenstr.

Argentinierstr.

*Schwarzenberg-
garten*

*Botanischer
Garten*

*Belvedere-
garten*

Schützeng.

Rennweg

Rennweg

Aspangstr.

Florag.

WIEDEN
IV.

Plößlgasse

Prinz-Eugen-Str.

Gr. Neugasse

Mayerhof-
gasse

★ **Oberes
Belvedere
Schloß**

Kölblgasse

Hohlwegg.

Mohsgasse

LANDSTRASSE
III.

Krongasse

Schaumburger-
gasse

Belvederegasse

Belvederegasse

Mommsengasse

Fasangasse

Even Mozart needs a break from selling tickets for concerts of his own music! A genius often plagued by hardship, the Mozart legend is still very much alive in his adopted city of Vienna.

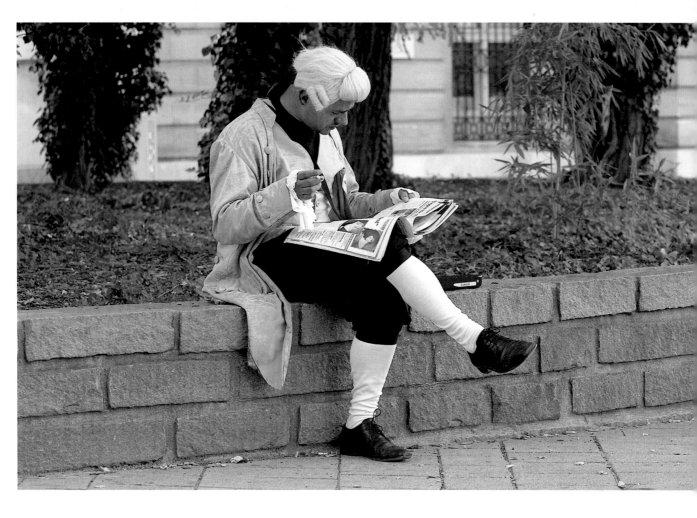

Front cover:
Top:
Café Museum was opened in 1899. The world-famous architect Adolf Loos styled the interior with a simplicity and objectivity which was totally unprecedented, earning the café the nickname of "Café Nihilism". Following extensive restoration a few years ago the coffee house once again shines in all its former glory.

Bottom:
The contrast couldn't be greater: on the right the age-old cathedral of St Stephen's and on the left Hans Holbein's ultramodern Haas-Haus, the weathered facade of the former reflected in the gleaming glass of the latter. Initially the cause of great controversy, now the combination is another of Vienna's accepted architectural quirks.

Back cover:
The KunstHausWien houses the only permanent exhibition on the work of Friedensreich Hundertwasser in the world. The architect, famous not only for his buildings but also for his extrovert personality (once he appeared in public (un)dressed as Adam), had the idea for the museum himself.

CREDITS

Design
hoyerdesign grafik gmbh, Freiburg

Map
Fischer Kartografie, Aichach

Translation
Ruth Chitty, Stromberg
www.rapid-com.de

Printed in Germany
Repro by Artilitho, Trento-Lavis, Italy
Printed by Ernst Uhl GmbH & Co. KG,
Radolfzell am Bodensee
© 2008 Verlagshaus Würzburg GmbH & Co. KC
© Photos: János Kalmár
© Text: Michael Kühler

ISBN 978-3-88189-729-7

Details of our full programme can be found at:
www.verlagshaus.com

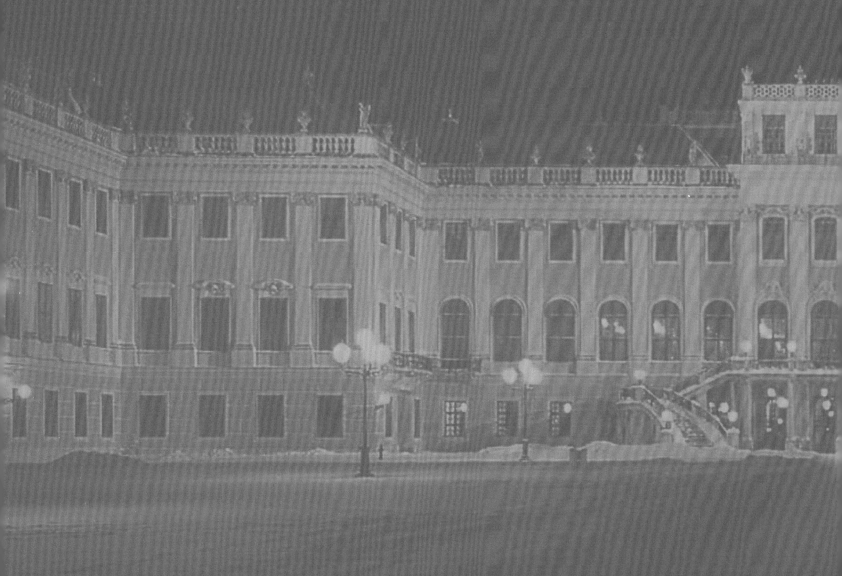